IMAGES
of America

MIDDLESEX
BOROUGH

Peter J. Dishin

Catherine C. Ferris

Robert A. Ferris

Edward J. Johnson

Mary L. Johnson

Alex Morecraft

Jack Van Doren

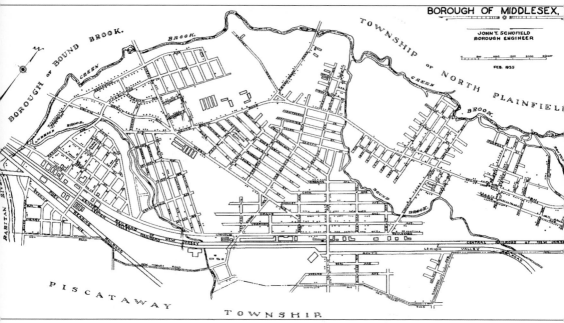

This 1935 map of Middlesex Borough was prepared by John T. Schofield, who was the borough engineer at that time. The map was printed in a booklet prepared by Mayor John J. Rafferty to advertise the benefits of the town in an attempt to attract both people and industries to the town.

IMAGES
of America

MIDDLESEX
BOROUGH

Middlesex Borough Heritage Committee

ARCADIA

Copyright © 2003 by Middlesex Borough Heritage Committee.
ISBN 0-7385-1167-6

First printed in 2003.

Published by Arcadia Publishing,
an imprint of Tempus Publishing Inc.
2A Cumberland Street
Charleston, SC 29401

Printed in Great Britain.

Library of Congress Catalog Card Number: 2002115976

For all general information, contact Arcadia Publishing:
Telephone 843-853-2070
Fax 843-853-0044
E-mail sales@arcadiapublishing.com

For customer service and orders:
Toll-free 1-888-313-2665

Visit us on the Internet at www.arcadiapublishing.com.

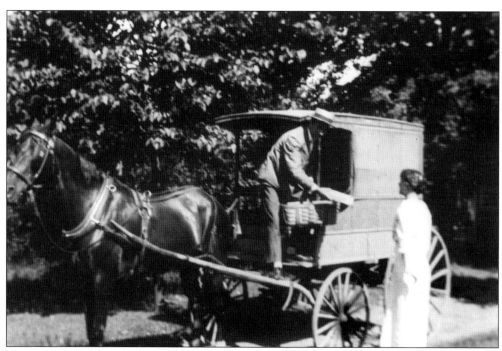

Henry G. Osterman converted his nursery business to a farm in 1914, since people needed food and not trees once the United States entered World War I. Osterman raised chickens and sold eggs for $1 per dozen from his delivery wagon, pulled by his horse Betsy. After the war, Osterman tried his hand at building and selling motorcycles but could not compete with Henry Ford's automobiles.

CONTENTS

ACKNOWLEDGMENTS

The Middlesex Borough Heritage Committee expresses its sincere thanks and appreciation to all organizations and individuals who were kind enough to share their photographs and their memories of Middlesex to make this book a reality. The committee extends thanks to the following: Robert Agans, Lou Andrews, Aileen Bendler, Anne Bitow, Mabel Boyer, James Boyle, Christine Bozzomo, Nicole Carter, Barbara Cochran, John Craig, Jack DeAngelis, Franklin Dentz, Emedal DiMura, Kate Diskin, David Eberhart, Myra Efinger, Patricia Engelman, Monica Esposito, Robert Feldman, Elsa Ferris, Robert Ferris, Nancy Fields, Hazel Giles, Barbara Glauner, Amelia Grek, Patricia Guidi, John Haelig, Hal Hanania, Joseph Hoski, Renee Hoski, James Iannetti, Edward Johnson Jr., Paul Johnson, Lorraine Kelly, John Kohler, Thelma Kohler, Michael Kozik, Patricia Lewis, Rita Lopa, Thomas Martin, Anna Matuskiewicz, Bruce McCreary, LeeAnn McNulty, Mary Meldrin, William Moore, Alex Morecraft, Arthur Morecraft, Ann Morgan, George Osterman, Richard Pachucki, Margaret Paradis, Dean Peak, Sherley Penrose, Angelo Petty, Lossie Pitt, Kenneth Pukas, Charles Reilly, John Reilly, William Rutkowski, Walter Ryan, Linda Schaffner, Walter Schneiderwind, Jacque Sebens, Joseph Shipula, Andrew Simpf, Kay Speer, Peter Staffelli, Trudi Suabedissen, Otto Tappert, Vito Tolomeo, Jack VanDoren, Beverly Weber, Ernest Wells, Edward Winters, Eleanor Wyckoff, and Joseph Zuccarelli. Thanks are also in order for the Borough of Middlesex, the Chronicle, the Community of Christ–Middlesex Congregation, Jehovah Witnesses, Middlesex Bible Chapel, the Middlesex Public Library, the Middlesex Borough Public School System, the Middlesex Presbyterian Church, Our Lady of Mount Virgin Roman Catholic Church, and the Plainfield Area Sewage Authority.

Middlesex Borough Heritage Committee

Peter Diskin
Catherine Ferris
Robert Ferris
Edward J. Johnson Jr.
Mary L. Johnson
Alex Morecraft
Jack Van Doren

INTRODUCTION

The early history of Middlesex Borough is interwoven with the history of Piscataway Township. Middlesex was a sibling of its larger neighbor until 1913, when it was incorporated as a separate entity. Originally, Piscataway was a vast piece of land located on the Raritan River. It was settled in the 1660s by settlers from Maine seeking religious freedom. The healthy and fertile area was purchased by the New England pioneers from friendly and peaceful Native Americans. By the 1680s, Pilgrims, Puritans, Dutch Quakers, and Baptists had migrated to the area, and all contributed to the development of the new territory.

It was also during this colonial period that the Bound Brook Road was a main highway for trade and travel between New York City and Philadelphia. Long before the first settlers arrived, the Native Americans were utilizing the River Road as a main trade route with the Dutch in New York City.

The Piscataway area during the Revolutionary War period, with its future Middlesex section and the terrain of the Watchung Mountains and the Middlebrook, is referred to by historians as a "cockpit of the Revolution." The area earned its name because it was the scene of numerous fierce battles between the colonists and the British soldiers and their hired Hessians. The British troops burned, ransacked, and plundered numerous villages and farms in this area in a vain attempt to stop the colonists from gaining their independence.

Piscataway became a township in 1789, and by 1868, its population had grown to 3,000. During that time period, the industrial development of the community was made possible. The first contributing event took place in 1831, when the Elizabethtown and Somerville Railroad received a charter for a line that would run through Piscataway Township. The Central Railroad of New Jersey took over the line in 1847. The railroad fostered the growth of numerous villages along its lines, which, in turn, caused the growth of industry. The western section of Piscataway, which later became Middlesex Borough, would grow to become the industrial heart of the township that, for the most part, was agricultural.

The aggressiveness of realty developers was also an important factor in the growth of the area. The initiative for Middlesex to take on an identity of its own began in 1896, when Silas Dewey Drake, a real-estate developer from Elizabeth, formed the New Jersey Mutual Realty Company and purchased farmland from John D. Voorhees. Drake divided the land into streets and lots for homes and industry. The first building he constructed on his real estate was his own office, next to the railway station. Soon followed the construction of three factories. The factories were the Hollingshead, Wertz, and Grauert Company; Franklin Paint Works; and Star

Incubator and Brooder Company. Through the efforts of Drake and other prominent builders, a post office, grocery store, and other buildings were constructed in the new section. Drake developed the section known as Lincoln, and his office, the three factories, post office, grocery store, and other buildings were all located on Lincoln Boulevard.

Silas Dewey Drake was a great admirer of Pres. Abraham Lincoln and had a statue of him erected in front of his realty office. It was officially dedicated on Memorial Day in 1898. For the next 15 years, that area was known as the Lincoln section of Piscataway. Other sections that were developed soon after were known as the Pierce Estates (in the East Bound Brook area), Dewey Park, and Beechwood Heights.

Between 1910 and 1912, George Harris, the Lincoln section representative of the Piscataway governing council, became increasingly disenchanted with the township's refusal to provide his section with basic services, such as streetlights, fire hydrants, and sidewalks. As a result, Harris organized a group of residents in his Lincoln area who began the movement to form a separate municipality. A committee formed and presented a petition for a new community to be named Middlesex Borough.

In May 1913, Middlesex Borough became a separate town through the action of the state legislature and local referendum. In June 1913, George Harris was elected as the first mayor and the first borough council was elected at the same time. Those elected to the six-man borough council were Max S. Bernstein, John J Campbell, Louis V. Paulson, T. Walter Sistry, Israel W. Stout, and Ludwig Wild. The first tax collector was Nelson M. Giles, and the first tax assessor was William D. Voorhees. The first two constables were Jesse Leone and Thomas J. Reidy. The two constables were the law enforcement officers for the new borough and were assisted soon after by five appointed marshals.

Middlesex Borough inherited its fire department from the Piscataway Fire Department. The men of the Lincoln section had organized a volunteer fire company in 1905, and it was this group that set the stage and example for the establishment of four other proud companies in the years that followed.

A number of schools were in operation before Middlesex was incorporated in 1913. The Harris Lane School was a one-room schoolhouse that stood on the corner of Union Shepherd Avenues. At one time, it was the oldest school in Middlesex County. The original Pierce school was built on the west side of Raritan Avenue in 1902 and was known as the East Bound Brook School House. The Parker School House was also used for instruction and was later converted into a two-family house on North Lincoln Avenue.

Thus, Middlesex Borough was formed.

One

DEVELOPMENT
OF THE TOWN

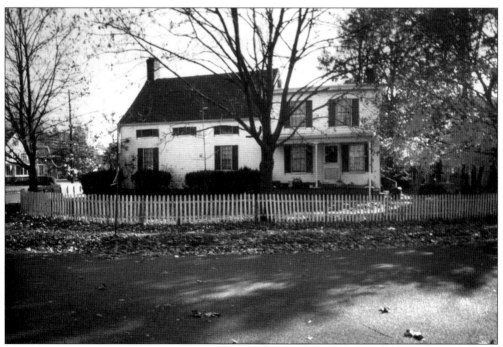

The Sebring House on Greenbrook Road is probably the oldest house in Middlesex. The house was once part of a farm that occupied more than 50 acres. The northern part of the farm (now a housing development) consisted of a meadow where livestock grazed. The Sebring Mill was located across the Green Brook, complete with a waterwheel, and was used to grind grain for many of the farmers in the area.

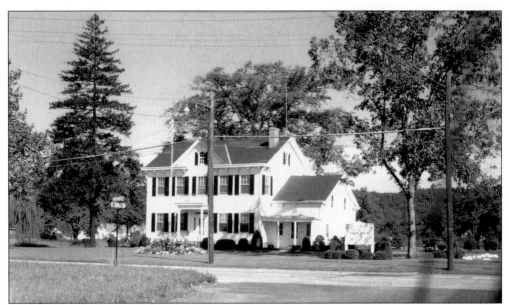

The sun shines brightly on the old borough hall, which was located near the corner of Lincoln Avenue and Bound Brook Road. The structure was built in 1837 and was known originally as the Conover home. The old borough hall was the scene of municipal affairs from 1948 to 1962. The new municipal hall and police station on Mountain Avenue opened its doors in October 1962. The old borough hall had become inadequate.

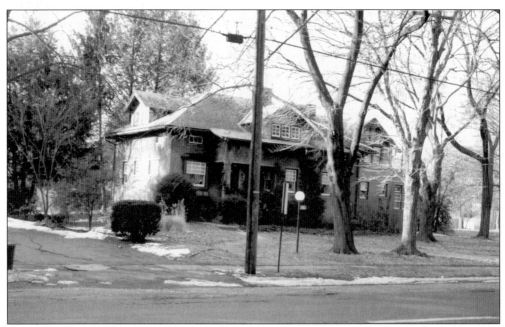

Pictured is the McCreary House on Hazelwood Avenue. For many years, Marion McCreary wrote the column "Middlesex Day by Day" in the *Chronicle*. Prior to this, the house was owned by George Lincoln, a former mayor of Middlesex and secretary of the board of education. The house was once the residence of Margaret Bourke White, who was a World War II combat photographer for *Life* magazine.

On May 30, 1898, the statue of Abraham Lincoln was erected in the old railroad plaza at the corner of Lincoln Boulevard and Mountain Avenue. Silas Dewey Drake, one of the forefathers of Middlesex, commissioned Alphonse Pelzer, a German immigrant, to create the statue. It cost Drake $700. Pelzer employed a technique similar to the one used by the French on the Statue of Liberty. The bronzelike copper model stands 7 feet tall on 13-inch feet.

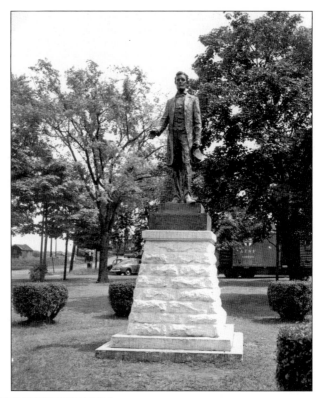

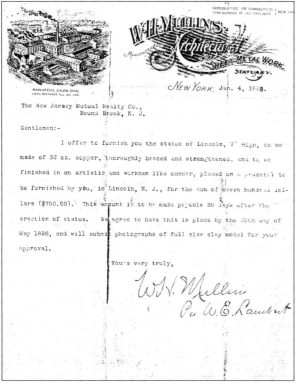

Silas Dewey Drake was the president and manager of the New Jersey Mutual Realty Company, a company formed by him for selling and developing real estate in Middlesex Borough. He wanted a statue of Abraham Lincoln to be located in the section of Middlesex that he was developing at that time, which he called Lincoln. He contacted W.H. Mullins, and this letter was the response he received from Mullins.

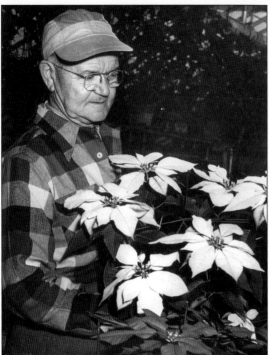

Henry Schnitzpahn, one of the many greenhouse owners in Middlesex Borough, is shown admiring some of the white poinsettias grown at his greenhouses. The greenhouse businesses were passed down from father to children for many years and provided jobs and a healthy environment for many residents of the borough.

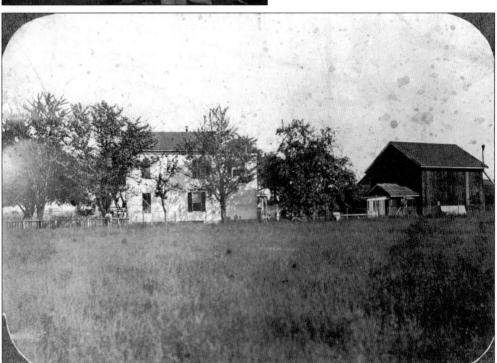

The rich soil of the valley between the Watchung Mountains and the Raritan River, where Middlesex is located, was a boon to farmers. This farm, shown in 1912, was located at 470 Harris Avenue. Tall trees protected and cooled the neat white farmhouse while the crops thrived on the warm Jersey summer sun and high humidity.

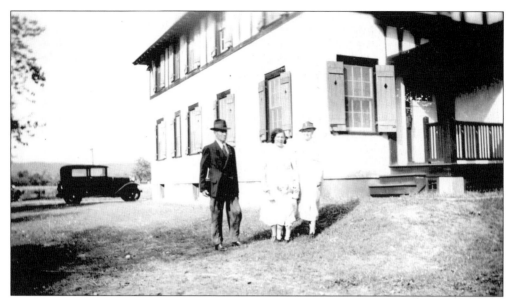

As Middlesex Borough grew and homes replaced the farms, apartment living became an option. In the 1920s, Hugh C. Pierce developed a section of land between Lincoln Boulevard and County Highway 28. This section, named Pierce Estates, included these apartments, which were Middlesex's first. These lovely, durable living spaces on Chestnut Street are still in use today.

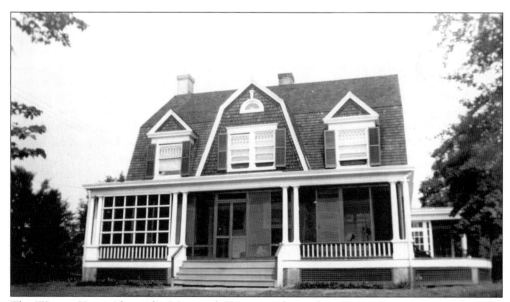

The Warren King–Alexander Morecraft House was located on Union Avenue across from the entrance to Victor Crowell Park. The original owner, Warren King, owned a chemical company that later became Calco-American Cyanamid. King also ran for governor. Morecraft was a building contractor who built the Brook Theater, stores, and an office building on Hamilton Street in Bound Brook.

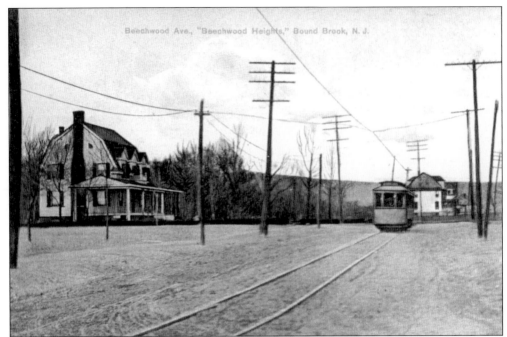

The Brunswick Traction Company, incorporated in 1895, obtained a franchise to lay track through Bound Brook, Middlesex, Piscataway, and Dunellen to the Plainfield city line. The transition from horse-drawn conveyances on muddy roads to electric cars on rails occurred at this time. This picture shows the trolley proceeding along Beechwood Avenue in Middlesex on its way to Route 28 and the terminus of the line in Bound Brook.

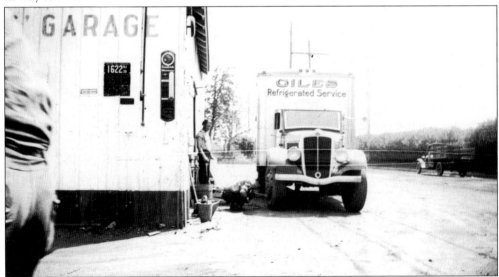

Two of the trucks used by the Giles Transportation Company are parked on Union Avenue in Middlesex in this early-1940s photograph. The truck parked next to the garage is one of the first refrigerated trucks to be operated in New Jersey and was used to keep orchids fresh while being transported from Thomas Young Orchids in Middlesex to East Coast shipping centers. The truck parked on the opposite side of the street is a stake truck used to deliver farm produce to local markets.

Early transportation in the borough was supplied by the assembly lines of Pierce Arrow, as evidenced by this elegant touring car built in the 1930s. Telephone and electric service had come to Middlesex by this time, as can be seen by the telephone poles and wires running along the side of Harris Avenue, one of the main thoroughfares of the borough.

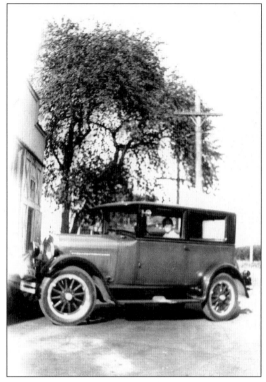

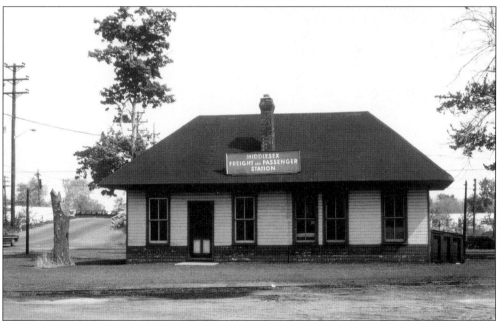

The Middlesex Freight and Passenger Station was located on Lincoln Boulevard near the statue of Abraham Lincoln. In earlier days, the building served as the Central Railroad of New Jersey station and was part of the railroad plaza where spectators watched the unveiling of the Lincoln statue in 1898. Middlesex residents and people from neighboring communities utilized the station for years for train transportation to New York City and back to Middlesex.

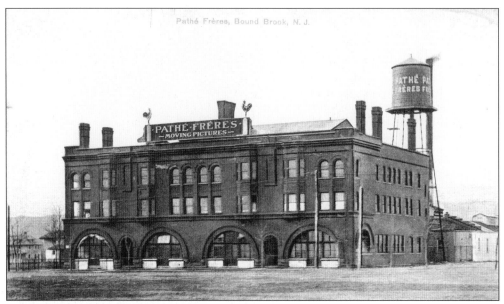

The Pathe Moving Picture Company operated on Lincoln Boulevard for many years. This company produced full-length movies in the 1930s. During World War II, it was famous for its newsreels, which were introduced by the crowing rooster and featured the mellifluous voice of Lowell Thomas keeping people informed of developments in Europe and Japan.

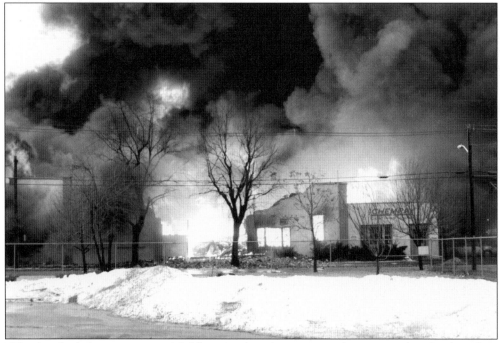

"The day the lights went out in Middlesex" is how longtime residents remember the day when the Chemray Chemical Company on Lincoln Boulevard burst into flames. The black smoke blanketed a major portion of the town. In the explosion that started the fire, one man was killed and several others injured. To extinguish the blaze, it required the assistance of more than 700 firefighters from 30 surrounding towns.

16

The Schnitzspahn greenhouses are pictured from the backyard of a residence on Stout Avenue. These greenhouses were among many that earned Middlesex the name "Flower Town." The members of the Schnitzspahn family were longtime residents of Middlesex, with family members still living in town. The family contributed in many ways to civic and business life.

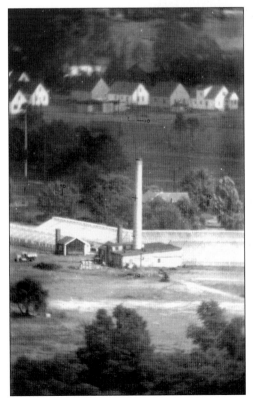

Shown here are the William Finck greenhouses as they looked in 1930. This aerial view was taken from the top of Watchung Mountain, looking east toward Union Avenue, where the greenhouses were located. The smokestack for the power plant, which supplied heat to the greenhouses, can be seen clearly in this picture. Family members took turns shoveling coal into the furnace to keep the greenhouses warm, both during the day and at night in order to maintain the proper growing temperatures.

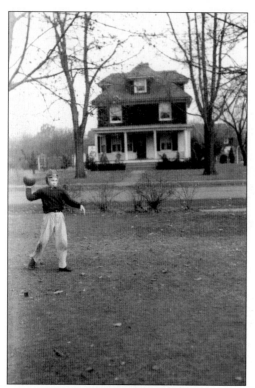

This house was the home of Sering Baker, the first treasurer of the Middlesex Savings and Loan Association. Like most of the homes on Hazelwood Avenue, it was built at the beginning of the 20th century from plans purchased from Sears, Roebuck and Company. In the foreground of this picture, practicing his football-passing technique at his home across the street, is Edwin Lincoln, the son of George Lincoln, mayor of Middlesex in 1941.

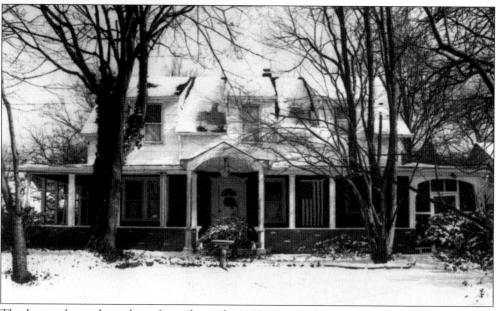

The house shown here dates from the early 1900s. Mr. Kalmbach, who was a janitor at the Watchung School, lived here in the 1930s and sold the property to the Sherados family, who lived in the home for many years thereafter. The home features a commodious front porch with several dormers in the front, is heavily landscaped to provide privacy, and is located near the Mauger elementary school. The Watchung Estates home development occurred shortly after World War II, and the once isolated house soon became surrounded by many houses.

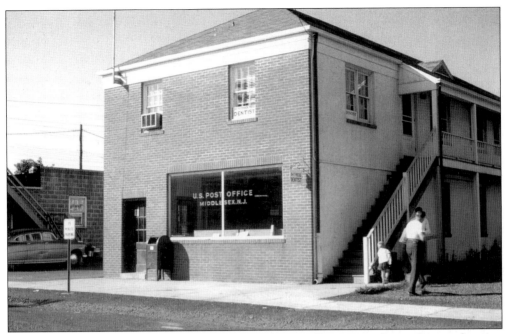

For a short period of time, the Middlesex Borough post office operated out of a storefront on the first floor of a building on Mountain Avenue across from the Lincoln Hotel. Dr. Frederick Hess had his dentist office on the second floor of the building. Fifteen-minute parking was permitted in front of the building to allow patrons to drop off and pick up mail.

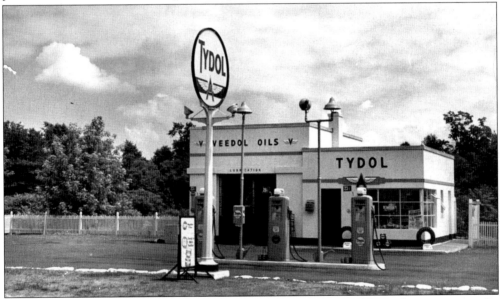

In the early 1960s, Jack Craig's "Flying A" Tydol gasoline station, on Union Avenue next to the Beechwood Heights Firehouse, was known by many in town as "Borough Hall Annex." People would stop by and ask questions or request help, and Craig would call Mayor Marty Matuskiewicz at his workplace at American Cyanimid to have the questions answered or the help provided. Much of the borough's business was informally conducted here. Notice that the prices at this time were 23.9¢ per gallon for regular gasoline and 25.9¢ per gallon for high-test gasoline.

Middlesex Borough was one of the few towns in the early 1900s to have the foresight to build a sewage-treatment plant. This building was the first office for the plant. To many of the residents at the time, the money spent for this purpose seemed to be outrageous. However, the construction of the treatment plant was deemed to be a great step for future generations. The building has since been sold for commercial use.

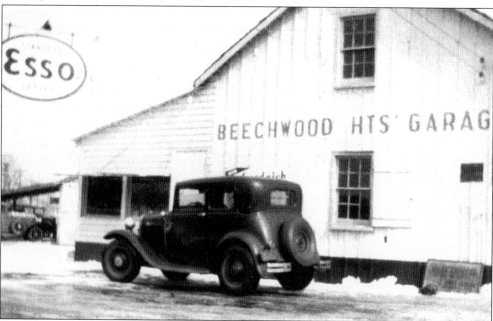

One of the earliest gas stations in Middlesex was the Beechwood Heights Garage, which dispensed Esso gasoline. The station was located at the southeast corner of Union and Harris Avenues. Shown here is a car parked at the side of the garage. The garage was a converted barn, which was originally part of the Giles Farm. The farm extended from Harris Avenue to Mannion's Corner at Greenbrook Road.

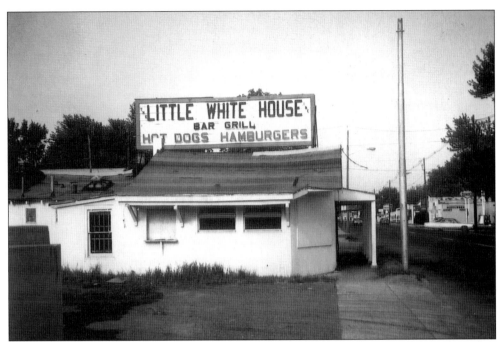

The Little White House was built by Herman Mann in the early 1920s and closed in 1982 under the control of a corporation. It was located on Bound Brook Road near Hallock Avenue. Through the years, the always popular bar and grill advertised the "best hot dog in town," hosted meetings for political parties, and was a Sunday gathering place for visitors from neighboring communities who always dressed in their best clothing.

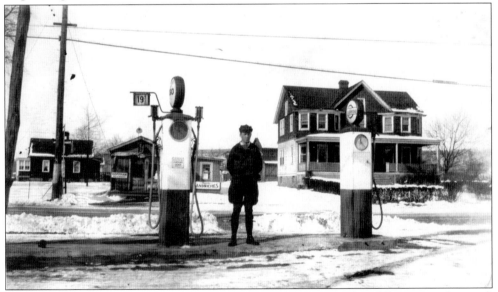

The only store that serviced the Beechwood Heights section of Middlesex was the small sandwich shop known as the Dew Drop Inn, Harry Gore's store, Frank & Shorty's, and Ryan's Market, depending on the time frame. The store was located on the westerly side of Union and Harris Avenues, across the street from the Esso gas station. Notice the price on the gas pump is 19.9¢ per gallon. Quite a difference from today!

Traffic was not a problem in the late 1930s in Middlesex Borough. One of the earliest delivery vans used in the borough is pictured here parked on Harris Avenue with two local youths relaxing on the fenders. The sparseness of the leaves on the tree and the hat on the lap of the boy to the right indicate that this picture was taken in the fall.

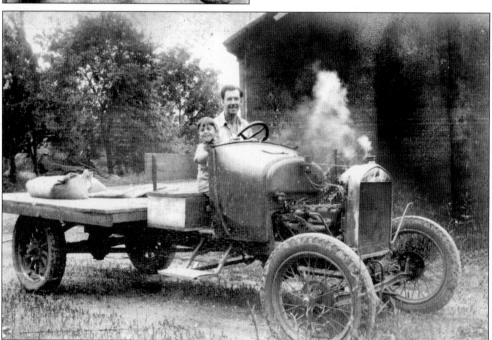

After a few years of hard work, this 1922 Model T Ford still pulled its weight. Pictured here in 1938 are Carl Finck and his nephew, William Ferris, on the William Finck property at 541 Union Avenue. Growing flowers in greenhouses was a difficult and sometimes backbreaking job, and any mechanical assistance that could be obtained was welcomed with open arms.

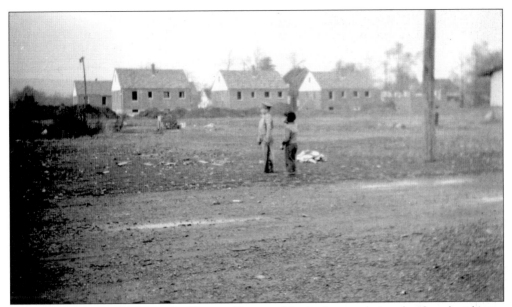

This 1953 photograph shows the Tappert Farm on Harris Avenue being developed with new houses as part of the post–World War II building boom that Middlesex experienced. The homes were built by local builders Ben Schwartz and Art Ludovice and are located on Benart Place and Pierrepont Avenue. Benart Place was named after the two builders by joining the two first names of the builders.

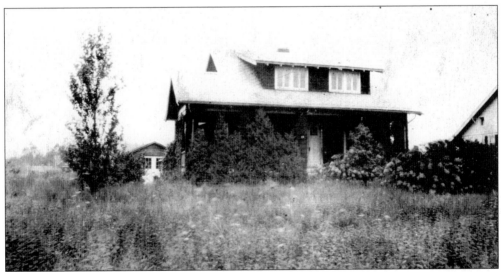

Shown here is a pre–World War I picture of the house at 95 Sherman Avenue, later changed to 319 Dorn Avenue. This was the home of Arthur Moore, who was an early justice of the peace in Middlesex Borough. Later, this became the home of Dorothy Morecraft (formerly Moore) and Kenneth Morecraft, who owned the home until 1993. Kenneth Morecraft was president of the Morecraft Corporation, which built stores, offices, and the Brook Theater on Hamilton Street in Bound Brook.

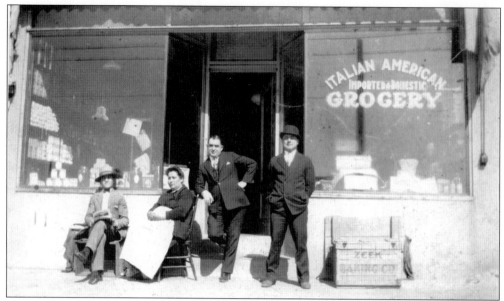

Shown from left to right, Anthony Donatelli, Nicolina Petty, Bobby Donatelli, and Angelo Petty drum up business in front of the Italian American Domestic and Imported Grocery in 1925. The store, located at the corner of Madison and Voorhees Avenues, was an example of several ethnic enterprises that flourished in the Lincoln section of Middlesex in order to service the large Italian community that had moved to the area.

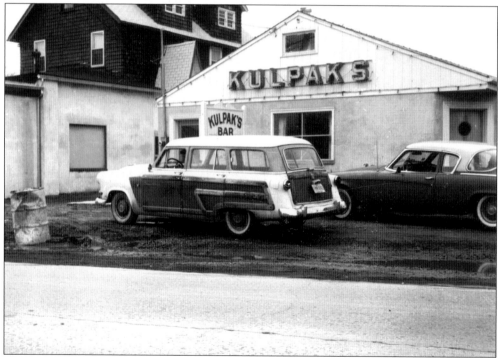

Along with many other well-established gathering places in the borough, Kulpak's served the needs of a faithful group of local fans. The business continued to thrive until the late 1950s, when the family decided to discontinue operations and use the entire building for their residence.

The A & P supermarket, which anchored the westerly side of the Middlesex Shopping Center, is under construction in this 1957 scene. The other stores that formed the original Middlesex Shopping Center on Route 28 opposite Greenbrook Road were W.T. Grant and later Shepard's, which anchored the easterly side of the center. The smaller stores served a variety of needs for local residents; the stores included a barbershop, a beauty shop, a liquor store, a florist, a jewelry store, a men's clothing store, a women's fine fashions store, a shoe store, a greeting card store, and a pizzeria.

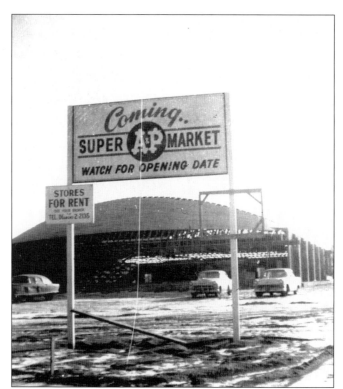

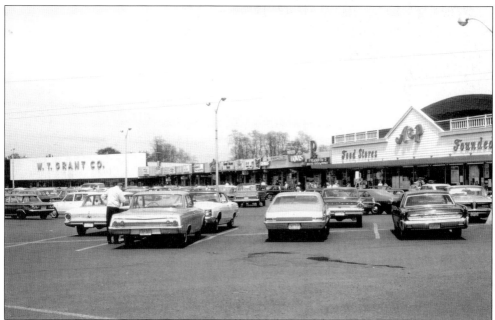

The Middlesex Shopping Center is shown as it appeared in the early 1960s. Remaining today and pictured in this photograph are the A & P, Middlesex Liquors, and the barbershop. It is the largest shopping center in town. Prior to the construction of the shopping center, the property housed a baseball field and the Sportsmen's Tavern. The tavern was moved about 150 yards west of this location after the advent of the shopping center.

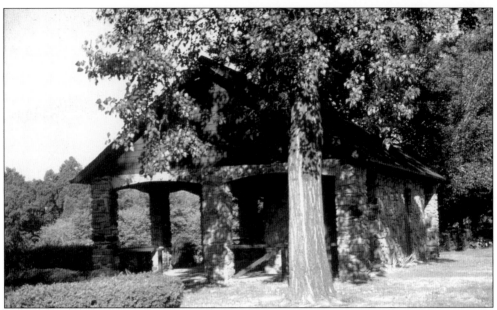

Victor Crowell Park, originally known as Willow Park, was built as one of the Works Progress Administration (WPA) projects initiated by Pres. Franklin Delano Roosevelt. Pictured here is the stone boathouse, which to this day is a landmark at the park. This building served as the meeting place for residents during winter days when skating and sleigh riding on the lake were popular pastimes. It still stands as the centerpiece in the redeveloped park today.

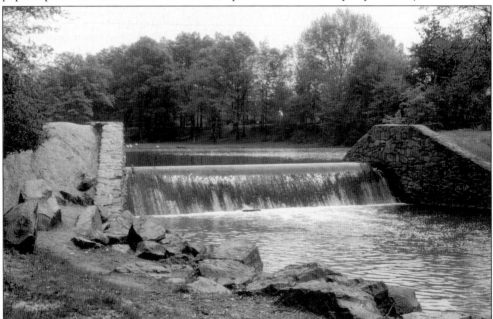

The falls at the western end of the Victor Crowell Park became a favorite spot for children to fish. In the late 1950s, the Middlesex Borough Recreation Commission sponsored fishing derbies, which were held below the falls. The brook was stocked with fish, and these outings provided many happy days for the children of the borough. Prizes were awarded in various categories.

Enjoying a quiet moment in 1935 is Mrs. Charles Reilly, sitting on her porch steps at her home on Runyon Avenue. An automobile of the period is also visible. Members of the Reilly family still reside in the same house today and continue the close family traditions of the Runyon Avenue area.

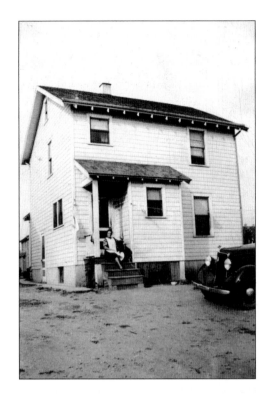

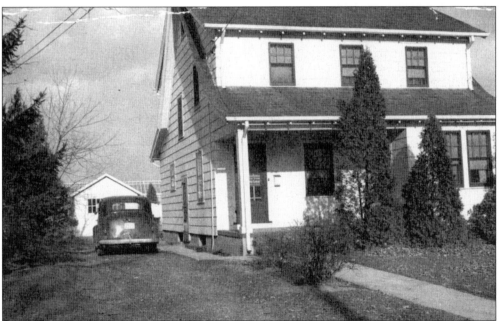

Pictured in this 1930 snapshot is the Boyle family home on Stout Avenue with the family car parked in the driveway. The Boyle family has a lifetime association with Middlesex Borough, and James Boyle and his family still live on Stout Avenue. Today, Stout Avenue is one of the older residential neighborhoods, and there are many young families as well as senior citizens residing in this area.

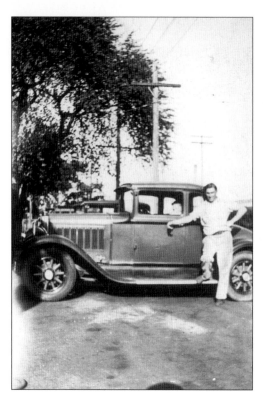

This driver has decided to pull off the road to park his car and take a break so he can have a picture taken of himself and his vehicle. Not very many people could afford such a luxury car in the days when this picture was taken. Running boards were a necessity in the early days but are anachronisms today. How times change!

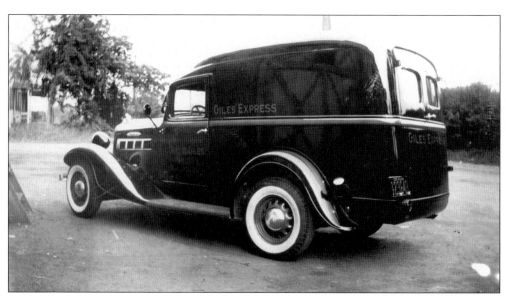

One of the earliest delivery vans in the borough was this 1936 covered van with whitewall tires, sculptured front end and rear fenders, a running board and radiator cap, and a protruding driver's rearview mirror. This vehicle was used for local delivery of groceries and food products.

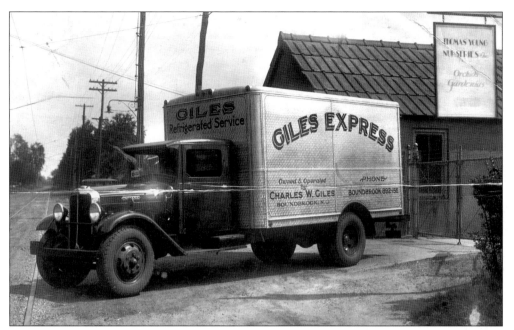

This picture illustrates the symbiotic relationship that developed between Thomas Young Orchids and Giles Express. Both establishments were located on Harris Avenue, and the greenhouses grew the best orchids on the East Coast. Charlie Giles expanded his trucking company and modernized his fleet of trucks to include "refrigerated service" in order to transport orchids from Middlesex throughout the eastern seaboard.

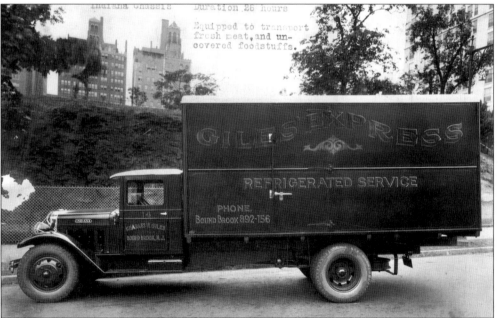

The fame of Middlesex was spread to New York City by the transportation firm of Giles Express, whose trucks brought orchids, fresh meat, and foodstuffs to the city on a daily basis. This picture was used to advertise the availability of dry-ice-refrigerated transportation, which could carry five tons for 26 hours, and shows a part of the New York City skyline in the background.

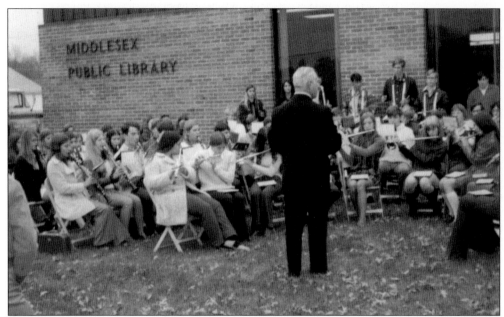

Middlesex residents were long content to use the facilities of the Bound Brook Library. In the early 1960s, a mayoral committee determined that there was a real need for Middlesex residents to have their own library. The first collection was housed in a storefront on Bound Brook Road with Virginia Lund as librarian. Middlesex Public Library's present building, adjacent to borough hall, was built in 1970. This picture shows the high-school band joining in the dedication ceremony.

The Middlesex Public Library opened the doors to its present building in December 1970. The original plans called for the building to be 50 percent larger than what was contracted at the time, but because of opposition, it was necessary to scale down the projected size of the building to get public approval for the project.

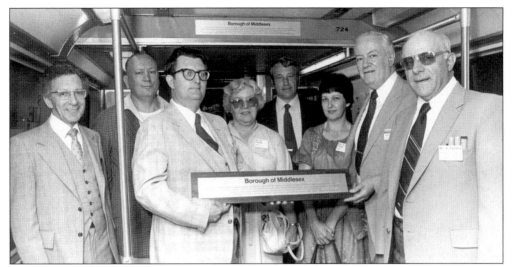

The Central Railroad of New Jersey named some of its commuter passenger trains for the towns through which the trains traveled en route to New York City. Shown here accepting a plaque designating this car for Middlesex Borough are, from left to right, Anthony Parenti, Richard Van Hook, Mayor Ronald S. Dobies, Marjorie Hanania (borough clerk), Carl Smith (zoning board chairman), Blanche Dobies, unidentified, and Police Lt. Hal Hanania.

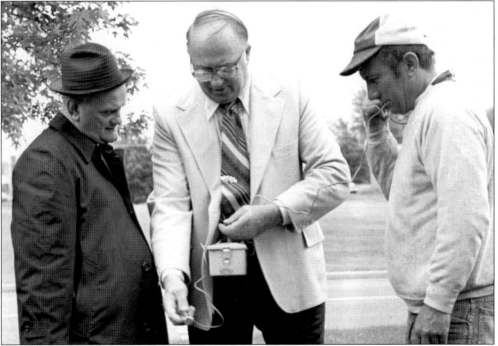

Standing from left to right, Rev. Joseph Fibner (pastor of Our Lady of Mount Virgin), Mayor Martin Matuskiewicz, and Ed Szarro (a parishioner of the church) check out the grounds of the church with a geiger counter to see if the soil has been contaminated by radioactive material. During World War II, uranium was processed in Middlesex as part of the Manhattan Project to develop the atomic bomb. Contaminated soil was moved from the site of the Middlesex Sampling Plant and used as fill in different areas of the town; one of those sites was the church property.

Biondi's Greenhouses were located on the north side of Union Avenue, at the westerly end of the borough. Biondi's Greenhouses could be easily identified because of the bright red flowers planted immediately in front of the complex. Although the number of greenhouses in Middlesex Borough has been reduced, the Biondi family continues the tradition today of growing beautiful and hardy flowers and offering them for sale to the general public.

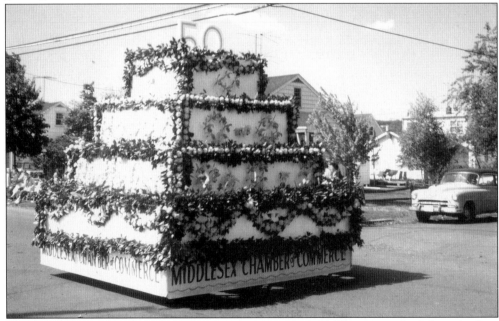

The Middlesex Borough Chamber of Commerce sponsored the Flowertown birthday cake float for the Golden Anniversary Parade in 1963. Middlesex was famous for its nurseries and greenhouses, and it was said that nowhere in the area was there soil as rich as that which had been washed and accumulated through the years on Middlesex farms at the foot of the Watchung Mountains.

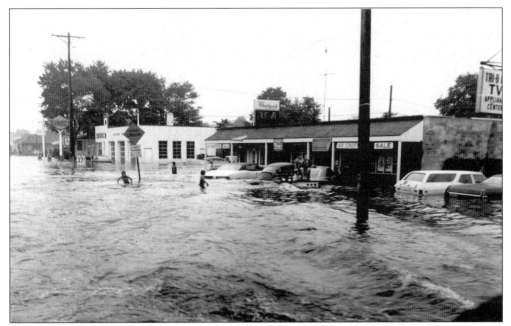

The soggy 1970s will always be remembered for the three floods in the summers of 1971, 1973, and 1975. Pictured here is the flooding scene on Bound Brook Road from the worst of the three floods on August 21, 1973. This flood claimed one life and caused over $1 million in damage. The nine inches of rain resulted in Middlesex being declared a disaster area, thus qualifying for state aid.

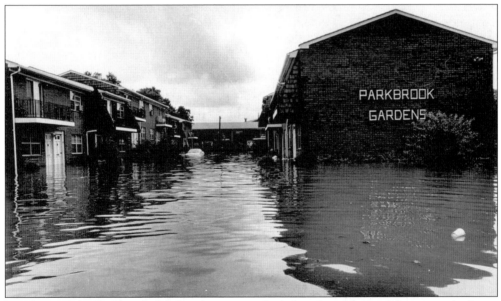

Residents of the Parkbrook Garden Apartments had their lives changed for a period of time because of the great flood of August 21, 1973. Apartment residents had to be evacuated to Middlesex High School on the other side of Route 28. The flooding was even more severe between First and Seventh Streets and Cap Lane and Rock Avenue, where 107 homes suffered damages to living rooms, garages, and automobiles.

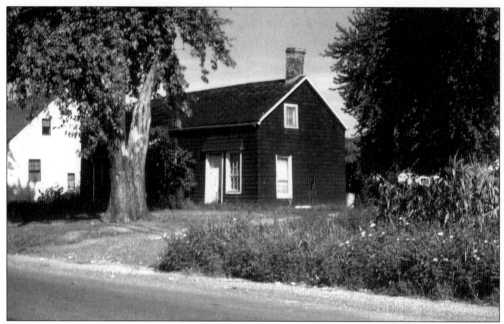

This is one of the first houses that was built on Harris Avenue. Wildflowers and a small tasseled cornfield on the side of the house are the only indications that this place was originally part of a large farm. Windows allowed cold weather to enter the home, but glass was expensive, so windows were kept to a minimum when building the family residences.

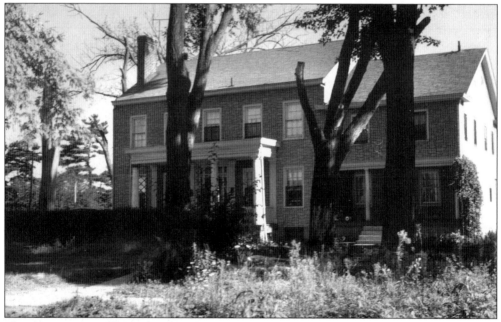

This house on Marlborough Avenue was one of the first homes built in Middlesex, when Marlborough Avenue was nothing more than a dirt road that led from Harris Avenue to this house. Subsequently, Marlborough Avenue was continued to Harris Avenue when the Watchung Estates development was built in the 1950s. The Oliver family was the original owner of this house.

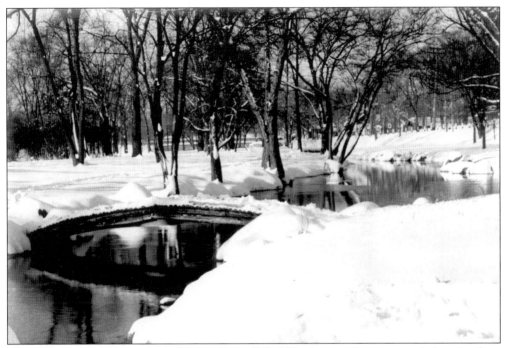

This 1938 view of Willow Park (Victor Crowell Park) looks west from a point below the dam, which was built to block the Ambrose Brook in order to create a lake. Ambrose Brook meanders through Middlesex and joins the Green Brook and flows into the Raritan River. The bridge used to wash away after each flood and, eventually, was not replaced.

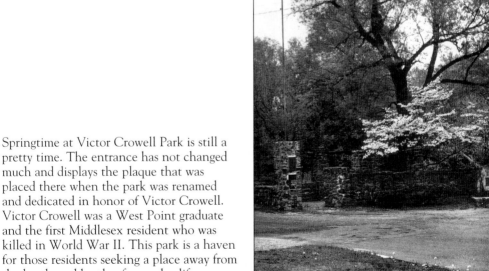

Springtime at Victor Crowell Park is still a pretty time. The entrance has not changed much and displays the plaque that was placed there when the park was renamed and dedicated in honor of Victor Crowell. Victor Crowell was a West Point graduate and the first Middlesex resident who was killed in World War II. This park is a haven for those residents seeking a place away from the hustle and bustle of everyday life.

Shown here is the new power plant built by Thomas Young Orchids. This was, at the time, a state-of-the-art facility. Thomas Young Orchids was the largest floral business in Middlesex. The firm also had a location in Chicago, Illinois. The buildings were razed in 1959 to make way for a housing development. The house in the center belonged to the proprietor. Eleanor Roosevelt often bought orchids at the Thomas Young greenhouses.

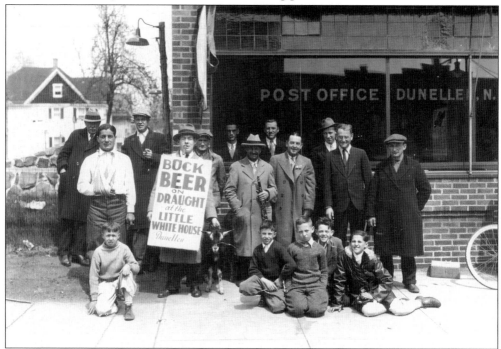

Pictured in front of the Dunellen post office in 1934 are Middlesex residents who marched in the Bock Beer parade. The parade originated at Herman Mann's Little White House on Route 28. Standing to the left of the Bock Beer sign is longtime Middlesex resident Angelo Petty.

A beautiful winter storm transformed this Dorn Avenue house into a picture postcard scene. Built in the 1940s in the Beechwood Heights section of Middlesex, this house is a graceful example of the new homes that were being built at that time. Beechwood Heights was originally part of the Guernsey Farm, which was already being developed in the early 1900s.

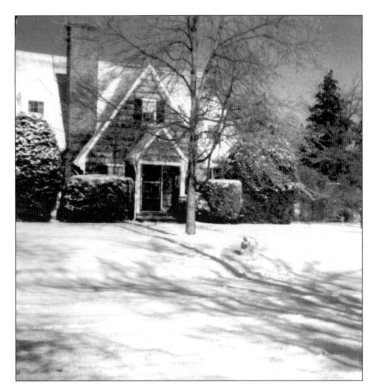

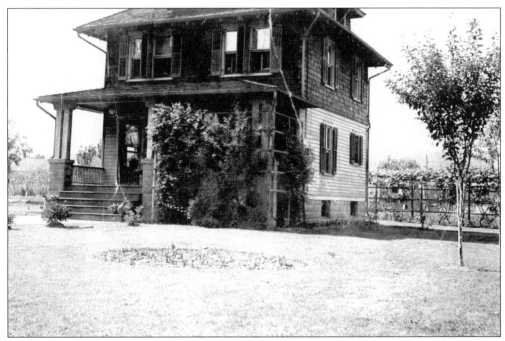

Pictured in 1924 is the Wertheim House, located on Grant Avenue. The house was built in the early 1900s. Margaret Wertheim married Ron Paradis, a steeplejack who helped install the lightning rod on top of the Empire State Building in New York City. Members of the Wertheim family are still residents of Middlesex.

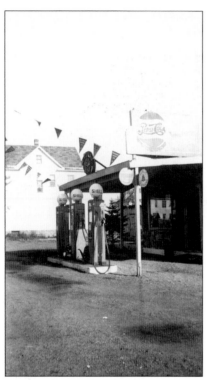

A Shell gasoline station with a traditional Pepsi Cola bottle cap as its advertising stands on the corner of Bound Brook Road and Lincoln Avenue. Fifty years ago, gasoline was less than 40¢ a gallon, and there were no long lines. The proprietor and the customers exchanged friendly conversation at the pumps.

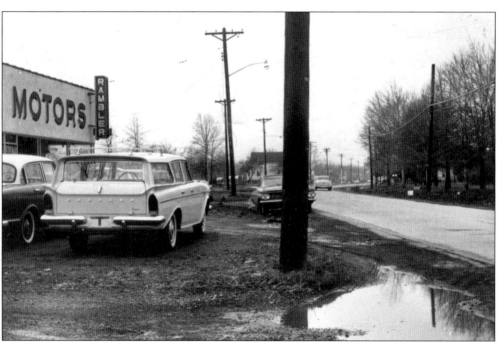

The only automobile dealership ever to locate in Middlesex was Mid Town Motors. The American Motors showroom was located on Bound Brook Road c. 1959. At the time this photograph was taken, Route 28 (Bound Brook Road) was a two-lane road. The property became an Arnold's Bakery outlet and then a video store.

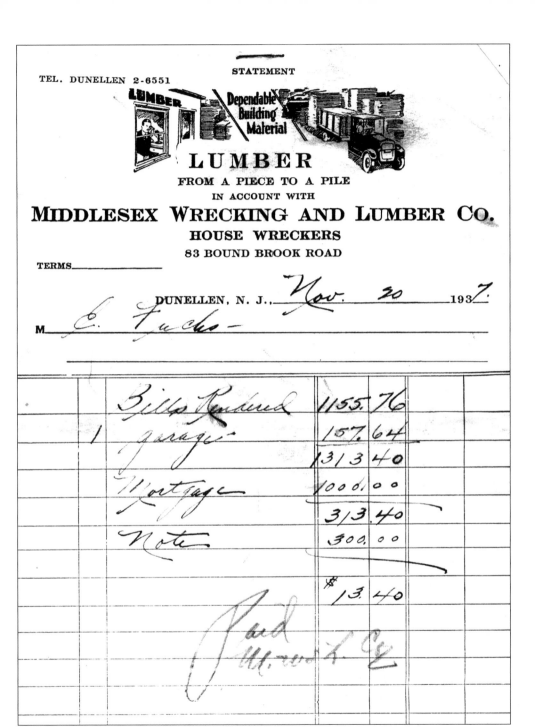

TEL. DUNELLEN 2-6551

LUMBER

Dependable Building Material

LUMBER

FROM A PIECE TO A PILE
IN ACCOUNT WITH

MIDDLESEX WRECKING AND LUMBER CO.

HOUSE WRECKERS
83 BOUND BROOK ROAD

TERMS_____

DUNELLEN, N. J., _Nov. 20_ 193_7_

M _C. Fuchs_ -

	Bills Rendered	1155.76	
1	garage	157.64	
		1313.40	
	Mortgage	1000.00	
		313.40	
	Note	300.00	
		$ 13.40	
	Paid		

The Middlesex Wrecking and Lumber Company, the predecessor to the present-day Middlesex Lumber Company, supplied many residents with lumber needed to build their houses. According to this document, the cost of lumber to build this particular house and garage in November 1937 was $1,313.40. The company took back a mortgage for $1,000 as security and an unsecured promissory note for $300. The actual cash outlay for the buyer was only $13.40 to purchase the lumber needed to build.

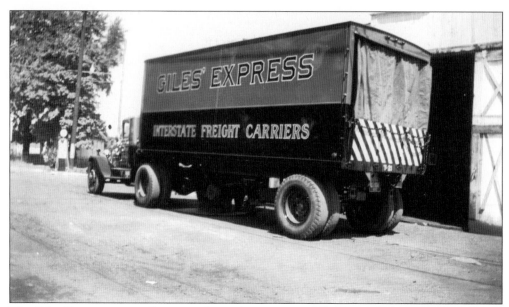

The Giles Transportation Company changed its name to Giles Express when it became one of the earliest trucking companies in the country to engage in interstate commerce. Charlie Giles, the owner of the trucking company, would often tell of driving over primitive roads by himself from New Jersey to California. He also described how many truckers of that time period made a habit of crossing state lines at night to avoid paying interstate taxes.

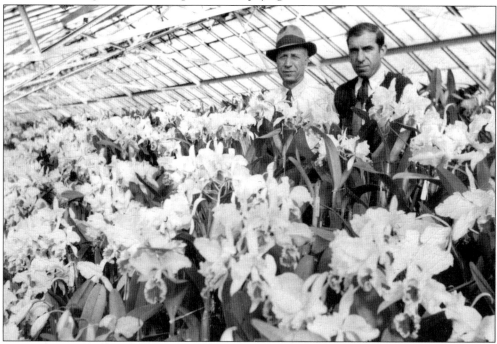

Thomas Young Orchids of Harris Avenue was the backdrop for this photograph taken in the 1940s. Surveying the crop of white hybrid orchids are Mr. Perranton (left) and Eugene Borin, both employees and Middlesex residents. What beauty was flowering in the middle of this small town!

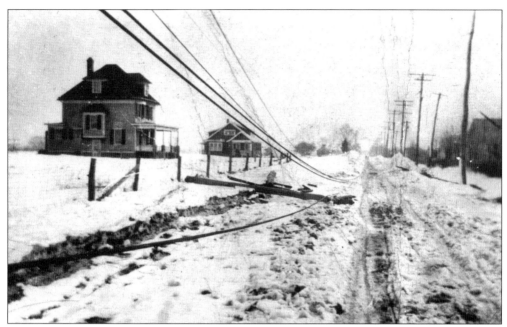

Snow-covered roads and downed power lines are features of this 1902 picture of Harris Avenue. The view is looking from Union Avenue going toward the direction of Lincoln Boulevard. The Giles House stands prominently on the left. The Giles name is an important part of Middlesex history. Nelson M. Giles was the first tax collector, and Giles Avenue is a street in Middlesex.

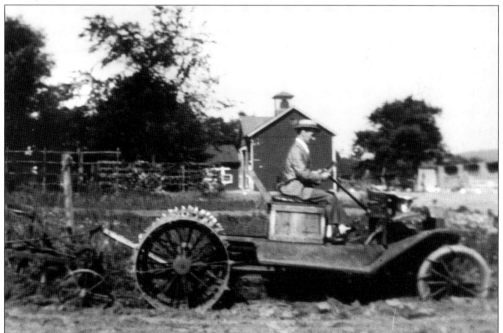

Typical American ingenuity of the early farmer is exhibited here as a 1915 Ford that has been converted to a tractor aerates, tills, and plows the soil at Osterman's Twin Brook Farm. The rear wheels have been converted to a spiked roller for aerating soil, and a plow has been attached to the rear of the vehicle and is pulled by machine power rather than horsepower.

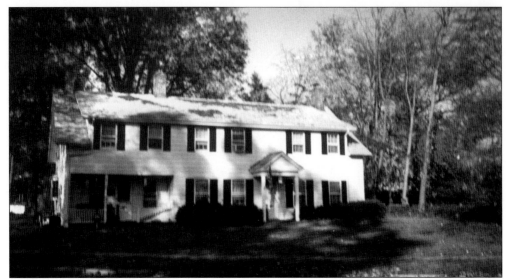

One of the oldest dwellings in Middlesex is the Lydecker House on Orchard Road. It was built in 1832 on the former Sebring Estate. Later, Lucius Guernsey purchased the farm and established apple orchards on the property. His daughter, Mary, and her husband, Chester, purchased the property in 1932. The name Lydecker has always been part of Middlesex history, with Chester A. Lydecker being the third mayor of the borough and the executive director of the Middlesex County Sewerage Authority. Lydecker Place is a street named in his honor.

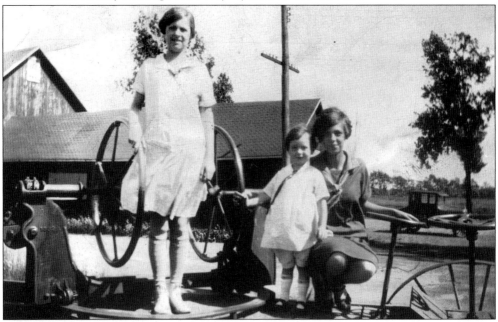

Pictured here are Kay Speer and her older cousins with farm equipment in front of farm buildings on the property known then as Mannion's Hotel, which was located at the corner of Greenbrook Road and Union Avenue. The hotel (not shown) was to the right of the picture and was sold by Martin Mannion to George Cantley, who renamed it the Manor House. The hotel was one of the original landmarks of the borough and provided housing to many itinerant salespeople and temporary residents passing through the borough.

Two
PUBLIC AND CIVIC
ORGANIZATIONS

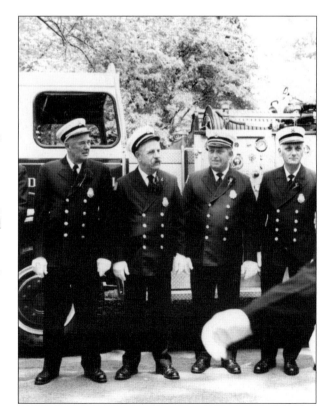

The outstanding leadership of the Middlesex Fire Department has been recognized throughout the years. Pictured here are four former chiefs who, along with their department's members, were totally dedicated to the safety and well-being of Middlesex Borough residents and town property. From left to right are John Wirth, John Craig, Darrel Dent, and Joseph Leccese. Each year, the various fire companies in the borough elect officers for the forthcoming year; this guarantees that experienced firefighters are elected to serve the borough after they have put in their time and learned their jobs well.

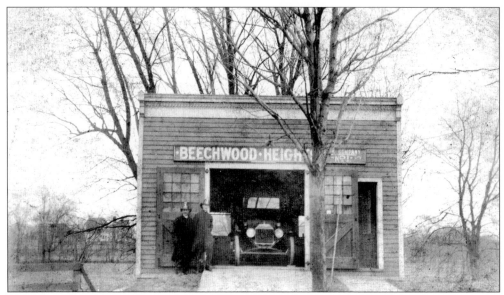

Beechwood Heights Fire Company No. 1 was formed on May 26, 1908. The land on which the building was located was deeded to the company by Nelson Giles for $100. Silas Dewey Drake was elected as the first chairman of the company; other original members were Max L. Wirtz, Augustus C. Ramsey, Clinton Carey, William B. La Rue, Edgar Grauert, William Betsch, Nelson M. Giles, C.R.C. Sours, Charles L. Staples, and Alfred H. Posselt. Shown here are two of the local firemen standing by the front entrance of the building in 1917.

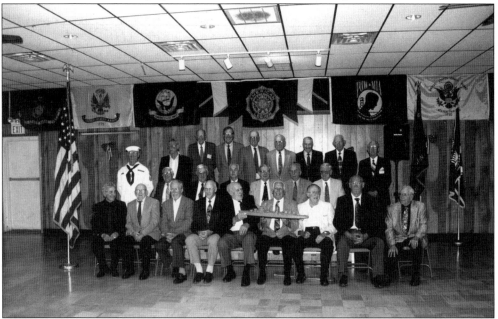

Members of the Middlesex Borough Veterans of Foreign Wars gather together to have their picture taken at one of their meetings. The organization has its own building in town, and the members enjoy the camaraderie engendered by the common experiences they encountered while serving their country in the armed services. One who has served his or her country often takes great pride in having done so.

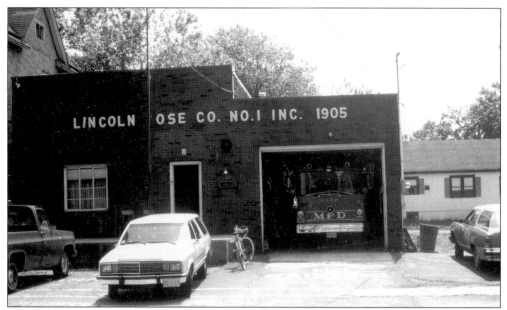

The Lincoln Hose Company, the first fire company in Middlesex, was established in 1905. It was formed from a section of Piscataway Township and was part of the Piscataway Fire Department. The Lincoln Hose Company building, pictured here, faced Mountain Avenue. It was replaced by an up-to-date building on the same property, but the new building faces Drake Avenue rather than Mountain Avenue.

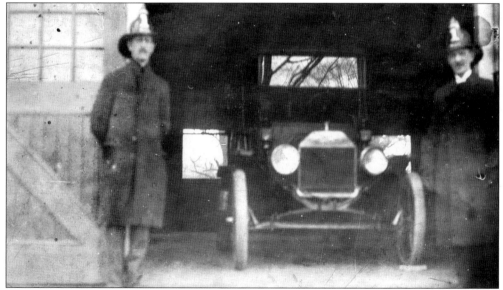

The Hugh Pierce family was responsible for the founding and early development of the H.C. Pierce Hose Company No. 3. The company was founded in 1908. The Hugh Pierce family deeded property on A Street to the company together with a hose reel and 500 feet of hose. Shortly thereafter, Dr. Ray V. Pierce gave the company an early-model car, which was converted into a fire truck and was used to carry the hose to fires throughout the town. The Pierce company purchased its first real fire truck in 1910 for approximately $850.

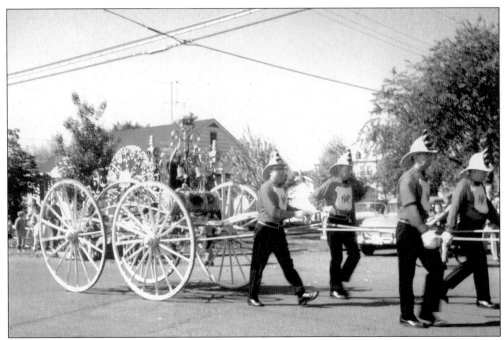

One of the oldest firefighting apparatus in the borough is on display by the fire brigade in the 50th-anniversary parade. This piece of equipment was drawn by men in the earliest days of the fire company, then by horses, and then by a car and was used to carry hose and other equipment used to fight fires.

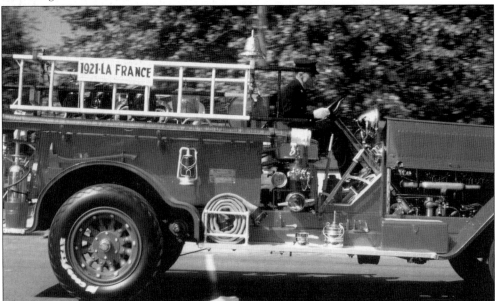

This was the first fire truck used by the Beechwood Heights Fire Company in 1929 and succeeded the car, which the firefighters used previously to tow the fire-hose cart. Notice that the ladder was long enough to reach the tallest buildings in the town, and the bell located immediately behind the driver was used to warn other vehicles that the fire truck was approaching and to alert people in town that help was on the way.

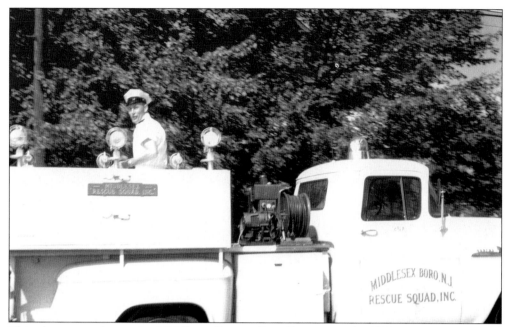

This vintage truck was the Middlesex Rescue Squad's entry in the 50th-anniversary parade. Squad member Bruno Seiler rode in the back of the truck and was available to extol the virtues of becoming a squad member to all who would listen. Compare this truck with the squad's present crash truck. What a difference!

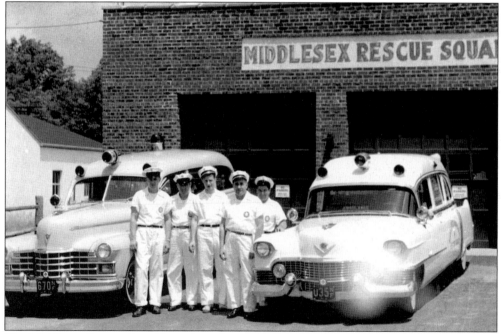

The Middlesex Rescue Squad has always been a strictly volunteer organization of good people helping others in serious situations. This is an early picture of volunteers and their vehicles. Standing in their fresh white uniforms, these members embody the honor of their calling. They took pride in the serious, frightening business of helping those in trouble.

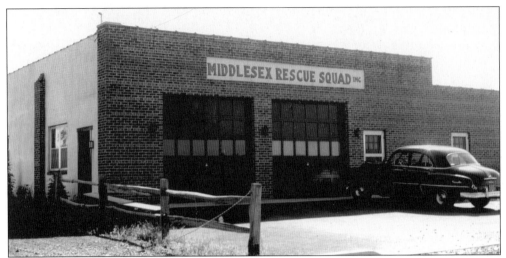

Harold Littell and Herbert Clausen organized a rescue squad for the borough in 1941, when James Marsh was mayor and the town had a population of 3,760 residents. The original squad had 11 members and held its first meeting on March 27, 1941, at the Beechwood Firehouse. It is believed to be the first rescue squad in the state to have women volunteers. The squad's first ambulance was purchased for $250 from the Somerville Rescue Squad, and this building was built in 1952.

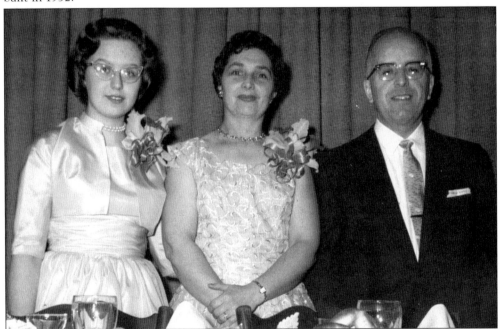

Emily (left), Amelia, and Joseph Zuccarelli pose on February 13, 1958, at a testimonial dinner to honor Joseph upon his retirement as the ninth mayor of Middlesex. He served as mayor from 1956 through 1957, and under his leadership, the borough was able to obtain the services of a bank to fill the needs of the borough. The federal government had initially determined that the National Bank of New Jersey could not locate a branch office in Middlesex, but Joseph went to Washington and battled the federal government and was able to convince the federal officials to change their mind. As a result, the first bank was allowed to open its doors in Middlesex.

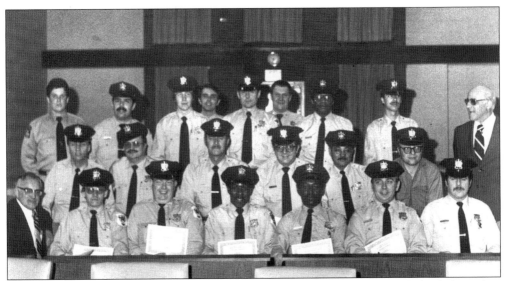

Middlesex Borough at one time had a group of dedicated residents who helped the police department perform nonessential duties. These duties included crowd control at picnics, church- and fire-department-sponsored carnivals and firework demonstrations, traffic duty, and providing assistance to the police at scenes of fires. This allowed the police officers to perform their essential tasks. Shown here are members of the Middlesex Borough Special Police, with Police Commissioner Harry Werner (seated at front left), receiving certificates that expressed the gratitude of the town for their work.

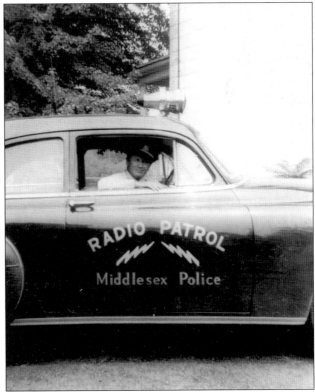

Chief Andrew Simpf began his career with the Middlesex Borough Police Department in 1941, and his starting salary was $1,400 per year. He served as chief from 1963 to 1981. When appointed as chief in 1963, Police Commissioner John "Doc" Sylvia described Simpf as a "modest man recognized by all in every level of law enforcement as a progressive person unafraid to implement new police techniques and science and yet having the ability to retain the personal touch needed in today's society." Only two other men previously served Middlesex as chief of police: William Fellows (1933–1935) and Gordon Fuller (1939–1963).

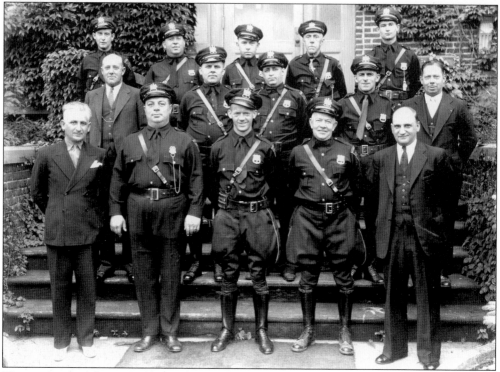

These men were the constables of Middlesex in the 1930s. This photograph was taken in front of Watchung School. Pictured on the right is Merrett Wertheim, who lived on Grant Avenue and was president of the Middlesex Board of Education.

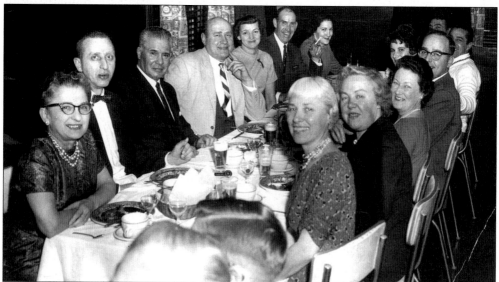

Sitting together at a retirement dinner for town employee George Peterson are town officials and other Middlesex citizens. At the table are, clockwise from the left, Agnes Sylvia, John Agans, John Sylvia, Bob Agans, Susan Thompson, Earl Thompson, Marian DiMura, an unidentified man, James DiMura, an unidentified woman, Norman Silk, Anita Silk, Evelyn Agans, and Marge Rabke. The festivities were held at the Lincoln Tavern sometime during the 1960s.

Chester A. Lydecker (left), the third mayor of Middlesex Borough and the first executive director of the Middlesex County Sewerage Authority, is shown here with deputy director and former Somerset County Superior Court judge Samual Chiarevalli (center) and sewerage authority attorney and former Middlesex Borough municipal attorney Edward J. Johnson. Johnson was also the Democratic county chairman for Middlesex County prior to David Wilentz and was elected to the state legislature in 1934.

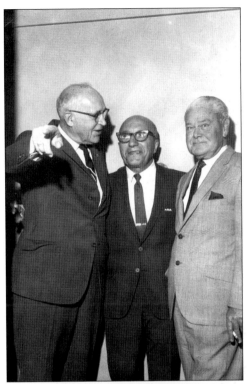

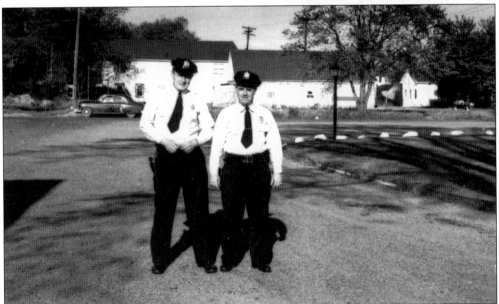

Pictured in the 1940s are two young patrolmen of the Middlesex Borough Police Department. Standing on the left is Robert Agans, who worked his way through the ranks to the position of captain. On the right is Andrew Simpf, who eventually became chief of police. Captain Agans took time off during World War II to serve with distinction in the U.S. Navy and returned to become one of the officers of the Middlesex American Legion Post No. 306. These two retired, dedicated law-enforcement leaders still reside in Middlesex.

AGREEMENT OF SALE

E. A. STROUT FARM AGENCY

NEW YORK CHICAGO DETROIT BOSTON MINNEAPOLIS JACKSONVILLE
PITTSBURGH OMAHA PHILADELPHIA

Agreement made the 12th day of March, in the year one thousand nine hundred
and Twenty, on property known as No. 449, Strout Farm Agency list at Bound Brook,
State of N.J.

Abram Giddes Decd.

BETWEEN Mary E.Giddes,Albert L.Giddes,Alonzo F.Brokaw,Executors of
party of the first part, and William O.F.Finck, and Nanse M.Finck,Lynbrook,L.I.N.Y.
part y — of the second part; said part y of the first part, In consideration of the sum of
Seventy Five Hundred Dollars,
to be fully paid as hereinafter mentioned, hereby agree to sell unto the said part y of the second part, the
following described property:

REAL ESTATE: Situated in the Township of Piscataway,County of Middlesex,
and State of New Jersey. Located on East Union Ave, known as Middle-
sex Borough, in said County. Also generally described by a certain
Deed, dated April Ist 1876,John H.Sebring and their Heirs, Also
recorded in the Middlesex County Clerks office of New-
PERSONAL PROPERTY: New Brunswick,N.J. on the IIth day of April 1876,
in Book of Deeds I59.Page,340 & Etc. Containing 9 acres and 2I/Ioo
of an Acre, More or less.

The Personal property to be included in the above Price, consists of
One Bay horse, all of the Plows, harrows, Wagons & everything in the
Barn, or around the Barn, Except a One Horse Plow, and the Corn in
the Crib. Also including all of the Buildings now on the property.
Taxes for the year I9I9 and previous years to be paid by the Party of
the First-Part, also Taxes to be aportioned up to May First 1920.

And the said party of the second part hereby agree s to purchase said property at the said consider-
ation, and pay the same as follows:
Amount paid on execution of this contract: $ 750.00 Check, receipt is hereby acknowledged,
Additional cash on delivery of deed, $ 1750.00 on the delivery of the Deed,
Mortgage for $5000,00 for 3 Years at 5-% Interest.

And the said party of the first part, on receiving such payment at the time and in the manner above mentioned,
shall at their own proper costs and expenses, execute, acknowledge and deliver, to said part y of the
second part or to their heirs or assigns a proper deed containing a general warranty and the usual full covenants
for the conveying and assuring to them the fee simple of the said premises, free from all encumbrance except those
mentioned herein, and except as follows: (insert here any restrictions or covenants running with the land.)

It is mutually agreed that should either party hereto fail or neglect to duly perform his part of this agreement he shall
forthwith pay and forfeit as liquidated damages to the other party a sum equal to ten per cent. of the agreed price of
sale, except that if said agreed price is less than $2,000, said sum shall be $200..
Deed shall be delivered on the First day of May — 19 20, at o'clock 2- M
at the office of J.J.Maier, in the City of Bound Brook, N.J.
The risk of loss or damage by fire or the act of God prior to the consummation of this contract is hereby
assumed by the part y First of the — part. The rents of the said premises (if any) shall be apportioned
to the first party up to the day of taking title. Possession to be given on or before the First day of May, — — 19 20,

And it is understood that the stipulations aforesaid are to apply to and bind the heirs, executors administrators
and assigns of the respective parties.

In Witness Whereof, the parties hereto have set their hands, the day and year first above written.

as to Mary E Giddes

[signatures] Mrs Mary E Giddes
 Witness Albert L Giddes First Party
 Alonzo F. Brokaw
 Witness Nanse M. Finck,
 William O.F. Finck Second Party

William and Nanse Finck entered into a contract on March 12, 1920, to purchase 9.25 acres of land on East Union Avenue in Middlesex from the executors of the estate of Abram Giddes. Included in the purchase price was the house, the barn and all of its contents, all of the buildings on the property, one bay horse, all of the plows, harrows, wagons, and the corn in the crib. The total purchase price was $7,500, and the seller agreed to take back a mortgage for $5,000. Abram Giddes originally purchased the property from John H. Sebring and the Sebring heirs on April 1, 1876.

52

Pictured here is Louis Staffelli, mayor of Middlesex from 1948 to 1954 and Republican county chairman of Middlesex County from 1953 to 1956. In his capacity as chairman of the Republican county organization, he was one of the most influential and powerful people in the county at that time. He also owned and operated the Middlebrook Diner on West Union Avenue in Bound Brook, New Jersey, from 1948 to 1960. In 1961, the diner was relocated to 1316 Bound Brook Road in Middlesex under the name Staffelli's Diner.

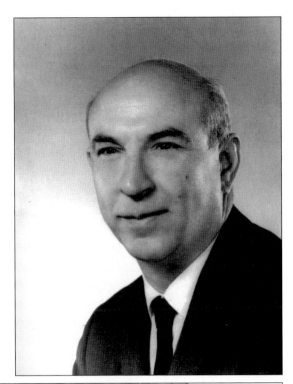

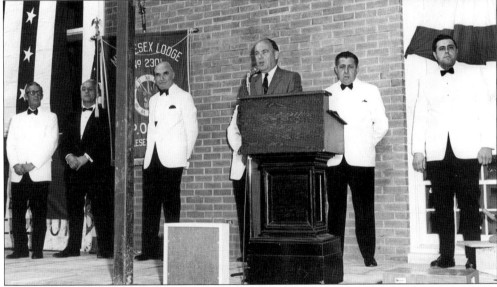

Mayor Charles Judson, Middlesex Borough's 12th mayor, who took office on January 1, 1964, is shown giving a dedication speech for the new Elks building at 545 Bound Brook Road as exalted ruler Thomas J. Crivello stands next to him at the podium. Mayor Judson was the prime mover for establishing a library for the borough, convincing the residents that they should not rely on Bound Brook for library services. There was vociferous opposition to the creation of a library in the borough from a group who called themselves the Friends of the Taxpayers and who felt that Middlesex residents could satisfy their library needs by using the Bound Brook Library.

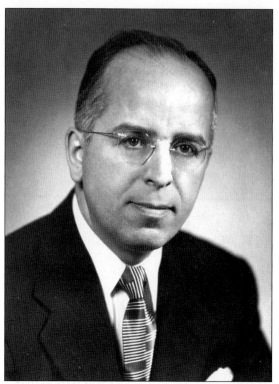

Joseph Zuccarelli has been a resident of Middlesex for 73 years. He and his wife, Amelia, have been married 67 years. In 1950, he was appointed to the borough council to fill an unexpired term and, in November of that year, was elected to that same position. In 1955, he was elected mayor. Joseph has dedicated his entire life to community involvement by holding public office, writing a history of the borough, leading and participating in many special events, and being a leader in church activities at Our Lady of Mount Virgin Roman Catholic Church.

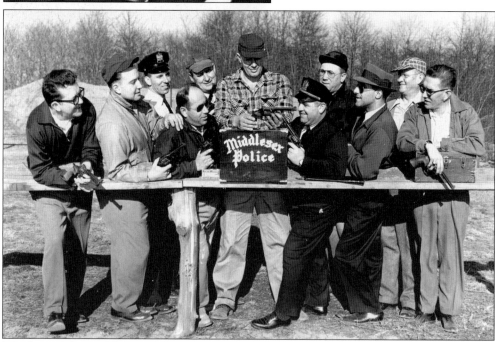

Members of the Middlesex Borough Police Department practiced target shooting at an outside facility in the 1960s in order to ensure that they maintained proficiency with their weapons. In the 1960s, there was vigorous competition between the surrounding police departments, each of whom had teams that competed to see which squad had the best sharpshooters.

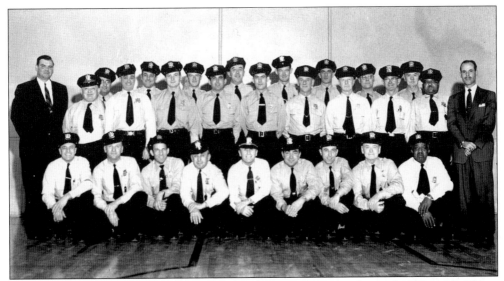

Officers of the Middlesex Borough Special Police are shown in the mid-1950s with Mayor William Klein (far left) and Police Commissioner Gordon (far right). These dedicated "specials" provided service to Middlesex in the form of safety, security, and traffic control at various community and school events.

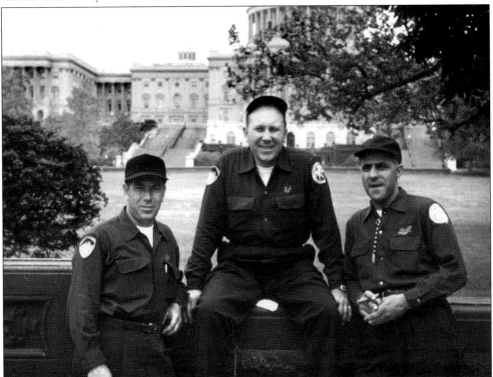

Shown here in view of the Capitol are, from left to right, Middlesex police officers Tony DeBartolomeo, Ed Kulpak, and Hal Hanania. The three men, along with Donald Lang, who was taking the picture, were members of the department pistol team, one of the best in the state in the late 1950s and early 1960s. The group earned a trip to Washington, D.C.

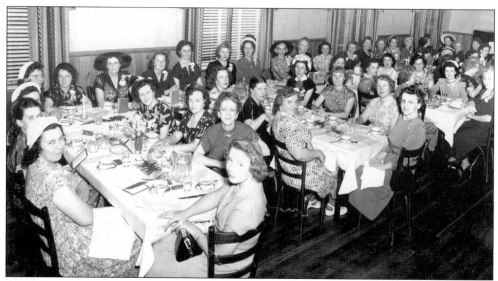

Members of the Middlesex Women's Club are gathered at a function in 1950. The club was founded in 1936 by 11 local women who met in the library of Watchung School. The first president was Mrs. Roy Allen. During the World War II period, the club studied international relations and legislation on public welfare, participated in the Bundles for Britain program, conserved and salvaged fats, tin, and silk stockings, served as canteen workers, and folded bandages for the Red Cross. The Middlesex Women's Club was always associated with charitable endeavors.

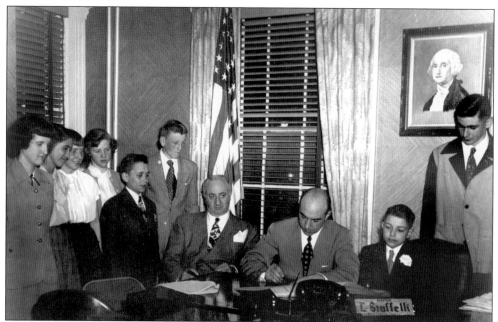

The 1950 officials for the annual Watchung School Youth Week Program are pictured prior to the regular Middlesex Borough Council meeting where they were sworn into office. Shown, from left to right, are Constance Eberhart, Sylvia Tolomeo, Helen Havens, Joyce Benes, Ralph Eberspacker, and David Pease (youth councilman), Joseph Mutnick (borough attorney), Mayor Louis Staffelli, Robert Ferris (youth council mayor), and Warren Cosgrove (clerk).

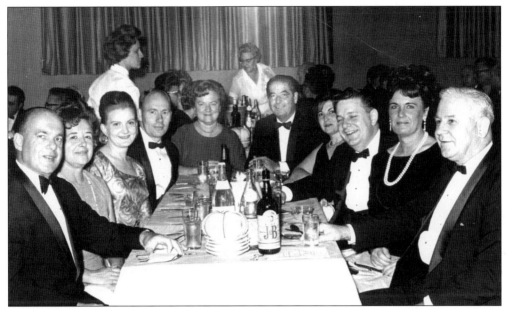

Middlesex Elks Lodge No. 2301 celebrates the annual Elks Ball. From left to right are former mayor Charlie Judson and his wife, Martha; Teri Hoski; Bruno Seiler; Florence Rafferty and former mayor Walter Rafferty; unidentified; Joe Hoski; and Evelyn and Charles Nagy. Established on May 3, 1964, with more than 300 charter members, the lodge had the largest number of charter members of any new lodge in the state. Its first meeting was held on Lincoln Boulevard before construction of its new building in 1964.

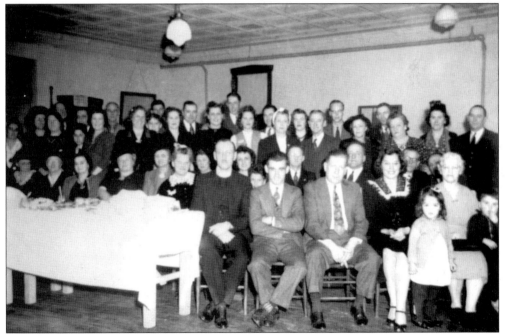

The neighbors of the Parker Firehouse are gathered together at the firehouse for a group picture on February 13, 1944. In the front row, in the center, is Reverend Maynard. The little girl in the front right corner is Lorraine Kelly.

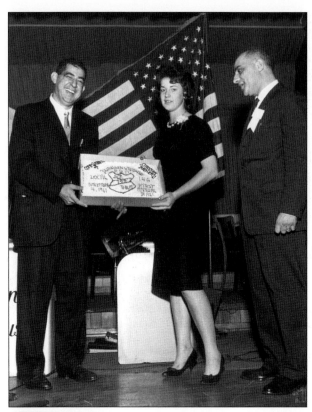

Members of the combined Middlesex Dunellen Patrolmen's Benevolent Association Local 146 join together with their wives and girlfriends at their first annual Policeman's Ball, which was held on November 4, 1961. Representing Dunellen in this photograph and on the left is Kayo Hamrah, and representing Middlesex is Hal Hanania.

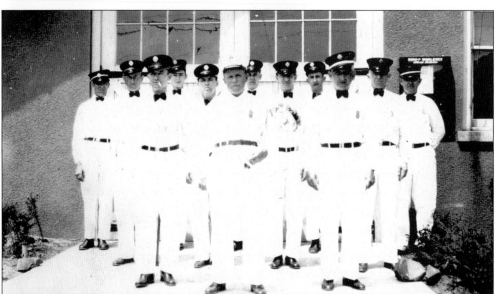

Members of the Parker Firehouse stand proudly in front of the old building on Bound Brook Road in the 1930s. From left to right are the following: (front row) Samuel Frank, Fred Erenback, and Emil Vogel; (middle row) Gus Barfous, William Allison, Howard Dentz, and Robert Dentz; (back row) Sam Taylor, unidentified, William Gerrity, M. Barfous, and unidentified. Samuel Frank also served as town magistrate.

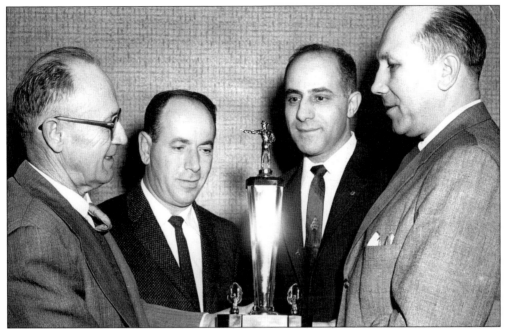

Police Chief Gordon Fuller (far left) presents a trophy in the late 1950s to members of the outstanding Middlesex Borough Police Department pistol team. The officers are, from left to right, Tony De Bartolomeo, Hal Hanania, and Edward Kulpak. They moved up through the ranks and retired after many years of dedicated service to the security and safety of Middlesex citizens. The Middlesex pistol team was consistently one of the top pistol teams in the area and won numerous awards for accuracy with weapons.

The Middlesex Borough civil defense organization, under the capable leadership of William Engelman, displayed its truck and boat and set up the public-address system used for the Memorial Day parade. It was the civil defense organization that discovered there was uranium-contaminated soil in the area behind the present borough hall during a civil defense drill. The federal government eventually removed the soil at no cost to the borough. Mayor Ronald Dobies spearheaded the cleanup effort.

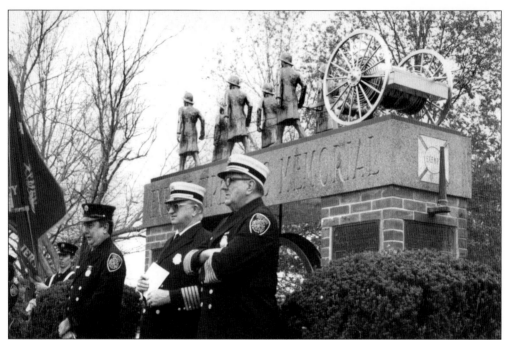

Mike Duffy (left), Marty Matuskiewicz (center), and Bill Engelman stand in front of the new Exempt Fireman's Memorial, which was dedicated to all those people who have served as volunteers in the Middlesex Borough Fire Department. The memorial commemorates the service of these people and features the hose cart, which was one of the oldest pieces of equipment used by the firemen, being pulled by six stalwart individuals garbed in old-fashioned uniforms.

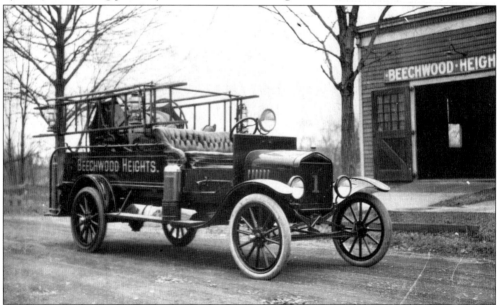

Pictured here is the converted Model T Ford, which was used from February 16, 1917, until November 1, 1919, by the Beechwood Heights Fire Company to tow the hose cart from the firehouse to a fire. The automobile supplanted the men and horses that had been used previously for this purpose.

Joseph P. Hoski, the first exalted ruler of the Middlesex Borough Elks Lodge No. 2301 when the lodge was instituted in 1964, is shown here looking down at fellow Elk Edward Plock and poster girl Laura Catani, one of the many physically disabled children who are helped each year by this organization. Edward Plock was the chairman of the handicapped children's committee that year.

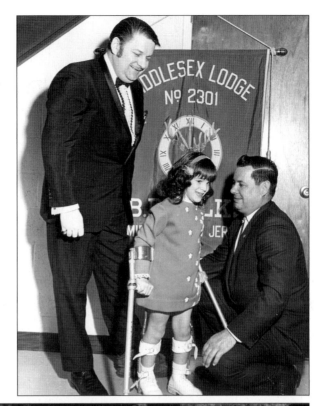

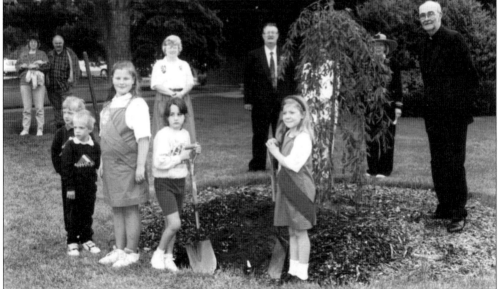

Girl Scouts are mobilized to plant a tree in front of the new library building. Lending their watchful support behind the girls are Councilwoman Sherley Penrose (in white), Mayor Ronald S. Dobies (in suit and tie), Councilwoman Mary Lou Viswat (partially visible, wearing hat), and Msgr. William Haughney (far right), pastor of Our Lady of Mount Virgin. Girl Scouts have been an integral part of the fabric of life in Middlesex for many years and have conducted many public service projects to help enhance the beauty of the borough.

This is the first fire truck purchased by the Beechwood Heights Fire Company; it was purchased in 1920 to replace the Ford car that the company had used previously to pull the hose cart. The hose cart was placed on the rear of the truck behind the front seat, and the truck was housed in the firehouse located on Union Avenue at the east end of the borough where it stands today.

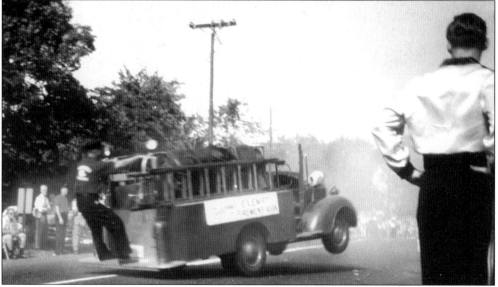

The comedy fire truck, designed by Bill Engelman, was built on a Model A Ford frame with scrap parts from various cars and trucks and was used in parades to amuse onlookers. The driver would jump off, and the truck would come up off its front wheels and spin around, surprising and delighting the audience. A 12-inch castor wheel mounted behind the rear wheels permitted the truck to spin when the front wheels were elevated.

Three

EDUCATION
AND CHURCHES

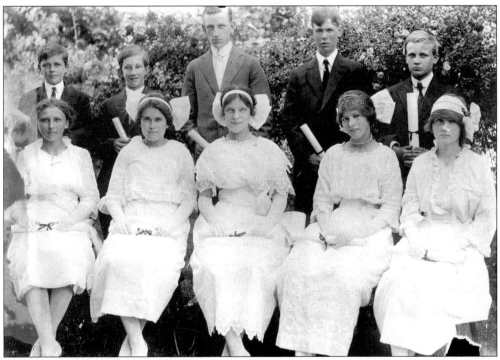

The first class to graduate from Middlesex schools, after Middlesex officially became a borough, was the Class of 1914. Pictured, from left to right, are the following: (front row) Frances Hazlin McLaughlin, Katherine Sebring Boddy, Josephine Baker Leonard, Anna Wild Lundgren, and Thyra Weimar; (back row) Chester Sours, Silas Brugger, Serring Baker, Holmes Marshall, and Dick Bakker. The students had a choice of continuing their education at either Bound Brook or Plainfield High Schools.

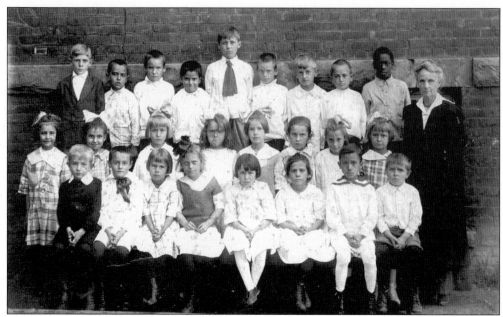

This is the first class of the original Pierce school on Raritan Avenue in 1916 with teacher Miss Henderson. The students are, from left to right, as follows: (front row) Tom Brown, unidentified, Louise Staats, Ethel Blauvelt, Lillian Campbell, Angelina Trutz, Louis Ferrand, and George Otto; (middle row) Dorothy Moore, Amelia Wuelfing, Elsie Weimar, Katie Folkman, Nellina Giles, and unidentified; (back row) Chester Bergen, unidentified, Nick DeFino, Joe Efinger, Leonard Huizing, unidentified, and John Alexander.

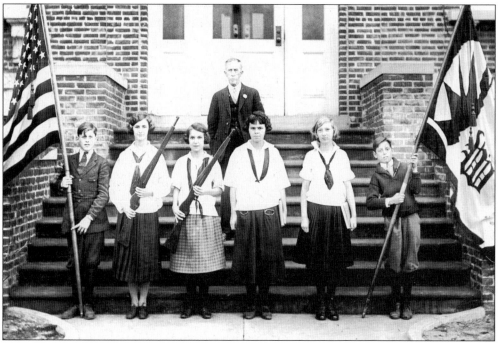

The 1925 Watchung School Honor Guard is pictured here in the uniform of the day, proudly standing with their school principal, William Love, in the background.

Von E. Mauger served as the Middlesex superintendent of schools from 1948 to 1971. Central School, Middlesex High School, and Hazelwood School were all constructed during his tenure of outstanding educational leadership. Central School was renamed the Von E. Mauger Middle School in 1975.

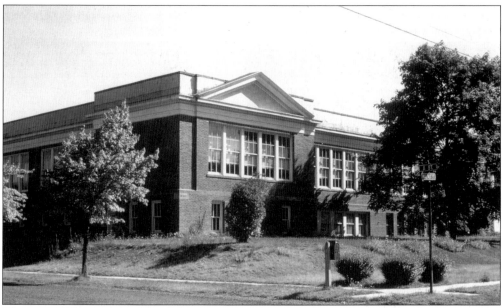

The original Pierce School was built in 1902 on the west side of Raritan Avenue and contained four classrooms, a distinct departure from the one-room schoolhouses of that era. It was later torn down, and a new Pierce School was constructed, located to the east of Raritan Avenue. Pierce School was sometimes referred to as the East Bound Brook School House. The building shown here was built in 1920–1921 on Walnut Street at a cost of $118,000. This school closed in 1983, and the building was demolished in 1984.

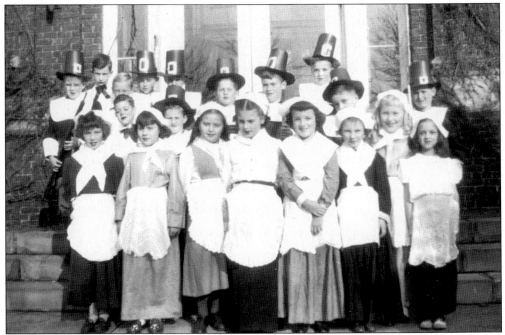

In 1949, this group of students from Pierce School celebrated Thanksgiving Day with a pageant, which was presented as an assembly program to the school. The children wore pilgrim hats and colonial costumes to portray their forefathers. Today, students perform similar pageants for their peers at the various schools in the borough.

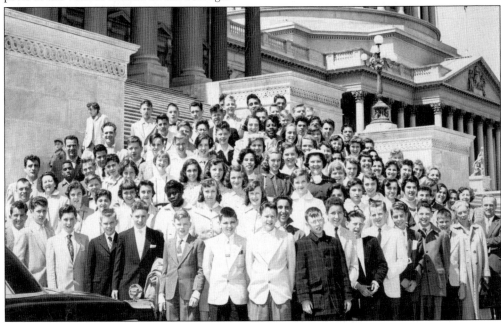

The Central School Class of 1956 stands smiling on the steps of the Capitol in Washington, D.C. They were on their eighth-grade class trip. The class is pictured with principal Ruth Houston and U.S. Congressman Peter Frelinghuysen, whose constituency included Middlesex Borough at the time.

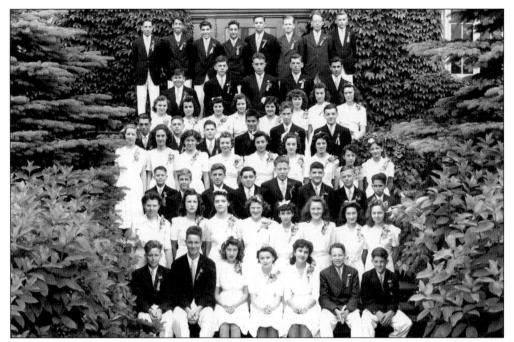

Girls in white graduation dresses and corsages, boys in dark suits, ties, and boutonnieres surrounded on both sides by lush green foliage are smiling happily as they pose for their final picture together as a class. This is the graduating class of Watchung School in 1943.

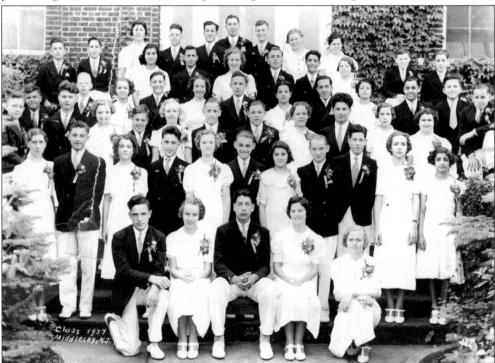

The 1937 graduating class of Watchung School is shown here. Included in this distinguished group are James Petty, Francis Sepesi, Hal Hanania, and Hazel Lydecker, to mention a few.

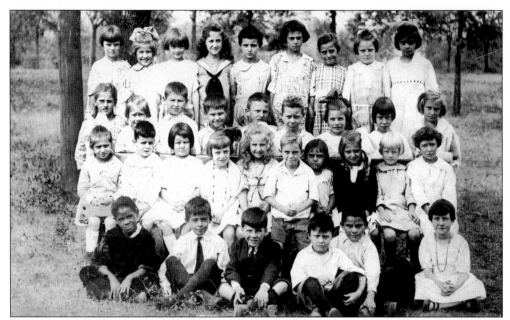

Children are shown graduating from the original Pierce School, located on the north side of Raritan Avenue adjacent to the brook. The original school was located in a park setting with numerous trees and shrubs in the area, and the grounds around the school were maintained as a park area. Although some of the girls had long hair, most of the girls in this picture had their hair cut short and, if you look carefully at the front row, you can see that there was one boy who made sure he did not get his picture taken. How would you like to have been his parent?

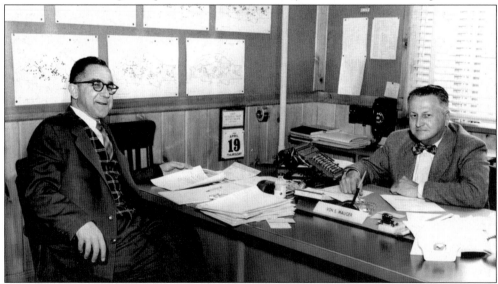

Superintendent Von E. Mauger (right) meets with Dr. Richard Ford, principal of Watchung School, on April 19, 1956, to discuss population growth in the borough. Notice the pins clustered in the maps on the wall showing the origin of the school population. The calendar indicates that the First National Bank of Bound Brook was still in existence, and the telephones have the old circular dial feature. There is also an old-fashioned adding machine on Mauger's desk. Three ashtrays on the desk indicate that smoking was prevalent in those days.

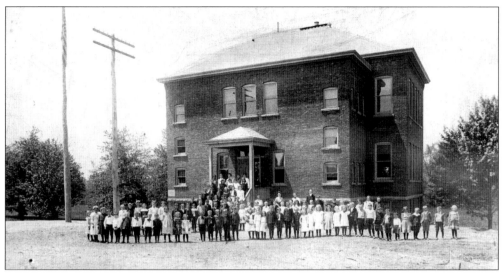

The first Pierce School, erected in 1902 and named in honor of Dr. Hugh C. Pierce, who donated the land for the school, contained four classrooms, which was a departure from the accepted one-room schoolhouses of that era. Two or three grade levels were taught in each room, and for many years, pupils were taught through the 10th grade. The two classrooms on the first floor could be changed into one large room by raising a partition on which blackboards were mounted. Dr. Pierce had an interesting sideline as a dispenser of "wonder tonics" and, in 1892, placed this advertisement in area newspapers: "Dr. Pierce's Golden Medical Discovery (for the liver, blood and lungs), $1.00: Dr. Pierce's Favorite Prescription (for woman's weaknesses and ailments), $1.00. Dr. Pierce's Pleasant Pellets (for the liver), 25 cents."

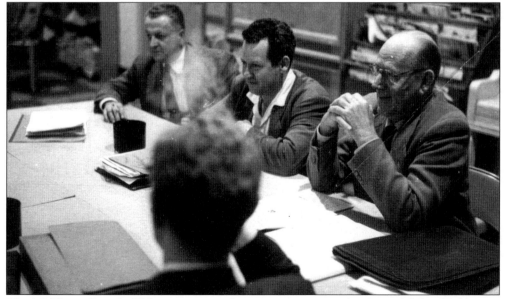

The Middlesex Board of Education is conducting a meeting in the Central School Library in 1958. Facing the audience from the meeting table are, from left to right, Von E. Mauger (superintendent of schools), Stephen Bitow (board of education president), and George Lincoln (board of education secretary). These three men are prominent in the educational history of the borough.

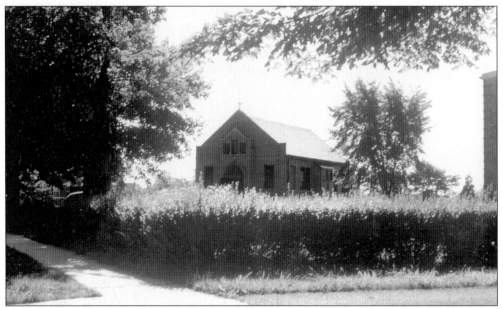

The original Our Lady of Mount Virgin Roman Catholic Church, constructed in 1925 on land donated by the Curcio family, was built on Harris Avenue. Hedges surrounded the church property and bordered the sidewalk, which ran from Harris Avenue to the main entrance. Middlesex Borough was a missionary parish serviced by St. Joseph's Church in Bound Brook prior to the construction of this church.

Our Lady of Mount Virgin was incorporated in July 1920 and was dedicated as a mission church of St. Joseph's Church of Bound Brook on August 15, 1925. The original church was 30 by 60 feet and seated 125 people. The church was a parish of 600 families by September 1943.

Rev. Emanuel Gauci was the second pastor of Our Lady of Mount Virgin and served in that position from 1944 to 1968, at which time he officially retired and was succeeded by Rev. Joseph Fibner. During his term as pastor, he supervised construction of the Our Lady of Mount Virgin elementary school (completed in 1955), the conversion of the old farmhouse adjacent to the church as a convent for the nuns teaching at the school, and the construction of the rectory, which served as the residence for the priests of the parish. He was a shrewd businessman who purchased most of the land that is now owned by the church, in addition to being a loved and respected cleric.

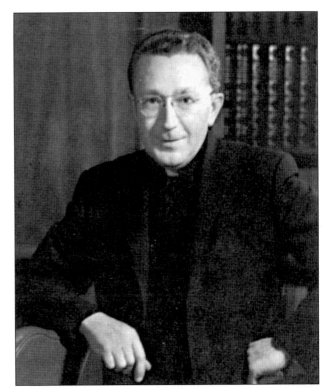

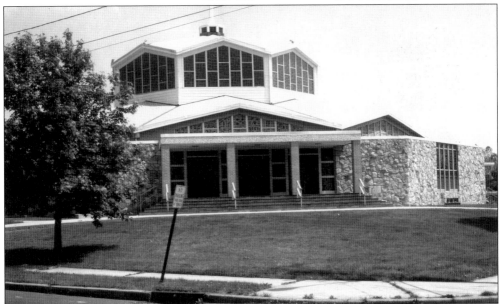

The present Our Lady of Mount Virgin church was built by borough resident Walter C. Rafferty, a former mayor of the town. The Rafferty Construction Company built several churches in New Jersey, but none provided more joy and satisfaction to him than this church in his hometown. Rev. Joseph Fibner served as pastor of the church at the time the church was built and led the fund drive that covered the cost of the new church. Joseph Zuccarelli and Edward J. Johnson Jr. were the co-chairmen of the fundraising drive at that time.

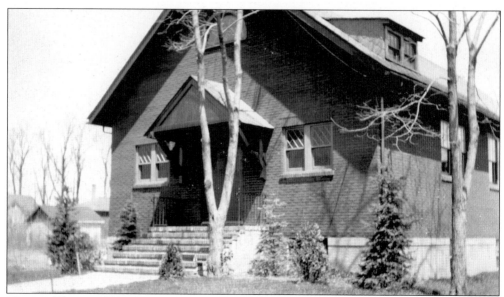

The Middlesex Bible Chapel, the original Protestant church in the borough, initiated its Sunday school on February 12, 1928. In 1936, the partially completed building was dedicated. Pictured here is the completed building in 1937. Today, the congregation still meets in the original church at 100 Fairfield Avenue.

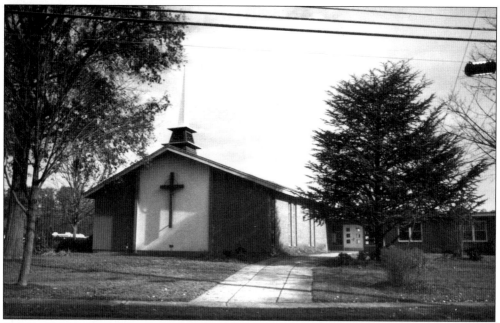

After a little more than a year of diligent work, in October 1961, the Presbytery of Elizabeth voted to organize a Presbyterian church in Middlesex Borough. Groundbreaking for the church building was held on July 4, 1965, and the first service was held in the new church on Christmas Sunday of that year. Spearheading the formation of this church were Ralph Chamberlin and Betty Ewing. The organizing pastor was Rev. Henry L. Jacobs. Middlesex Presbyterian Church is a warm, caring, Christ-centered community united in a common desire to lead others to a personal relationship with Jesus Christ.

The Kingdom Hall of Jehovah's Witnesses was built in 1959 on the corner of William Street and Blackford Avenue near the Piscataway Township boundary line. The Middlesex congregation was formed in 1956, when it separated from the Plainfield congregation. Samuel and Florence Squire of Middlesex Borough donated four lots in 1958, which served as the seed for the remainder of the property needed to house a new meeting hall. The first presiding minister was Charles W. Erlenmeyer.

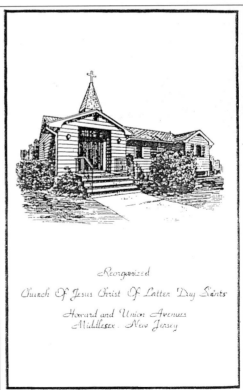

Reorganized
Church Of Jesus Christ Of Latter Day Saints

Howard and Union Avenues
Middlesex, New Jersey

The Reorganized Church of Jesus Christ of Latter Day Saints has occupied its church at the corner of Howard and Union Avenues for 27 years. The church has changed its name to the Community of Christ–Middlesex Congregation. Since it was originally organized, the group has offered services at several locations. The YMCA and YWCA of Plainfield were used for a while. The church purchased its present building from the Christian and Missionary Alliance Group.

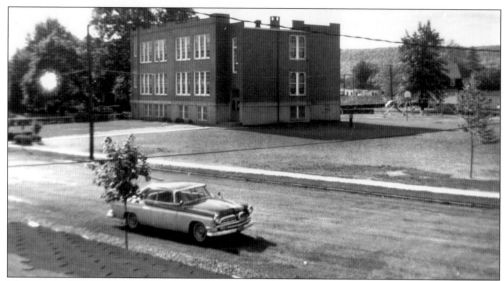

This view of Parker School was taken from Denton Place in 1956. The first Parker School was a two-family dwelling on North Lincoln Avenue. The present Parker School was built in 1926. The three-story brick structure was typical of schools of this age and had large hallways and wide stairways leading to upper floors. The board of education had wisely purchased a large tract of land in this area so they could place the school on the property and have adequate land remaining to provide a playground space for the children.

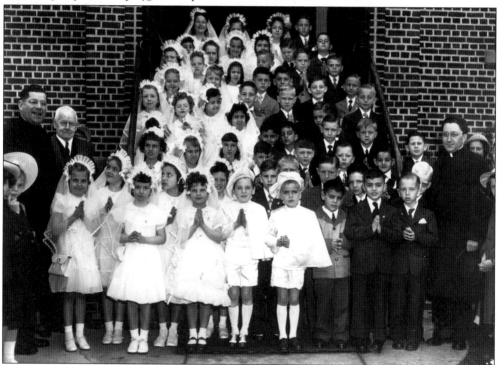

This is the first of many Holy Communion classes at Our Lady of Mount Virgin. Rev. Emanuel Gauci, the church's second pastor, is shown taking his place on the boys' side. In 1951, it was the style for girls and boys to be grouped separately for such pictures.

Four

PEOPLE

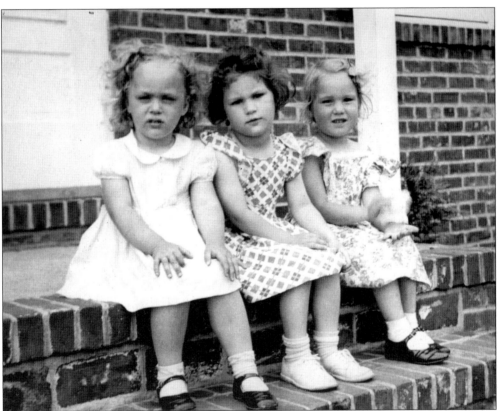

Three friends on Melrose Avenue relax on the front step. In 1948, little girls frequently wore dresses, white socks, and patent leather "Mary Janes." Looking very pretty for the camera are, from left to right, Joanne Russick, Eleanor Brown, and Lois Novack. Pinafores were especially popular in the 1940s.

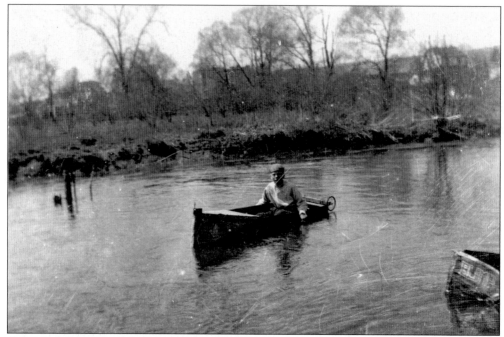

American ingenuity is exemplified by this picture of a boy relaxing in his homemade canoe. Notice the wheels attached to the stern; the wheels were probably used to make transporting the boat from land to water easier. Hopefully, the boy had his oars stowed away in the boat or else he would have to use his hands to paddle the boat to shore. Luckily, the shoreline was not very far away. Maybe he was going to investigate what happened to the boat shown at the right.

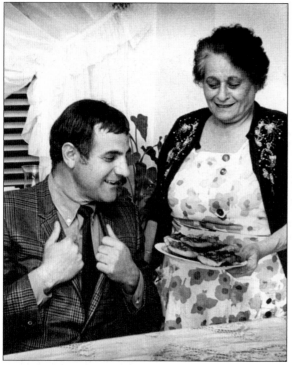

Tiger Andrews, raised and schooled in Middlesex Borough, is pictured visiting his boyhood home after achieving fame in California as a movie actor. "Tige" Andrews was a popular star on the television series *The Mod Squad* and also starred as the original Mack the Knife in the Broadway production of *Three Penny Opera*. A successful Hollywood and television performer, Tiger Andrews never forgot his Middlesex roots.

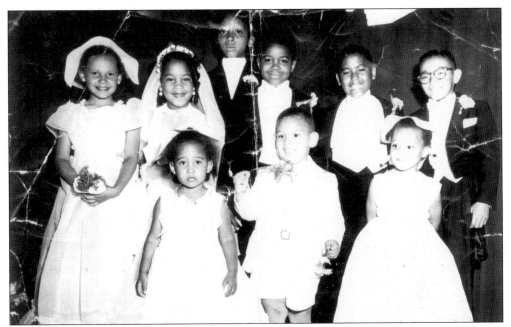

Children love to play dress-up, and grownups have always loved to provide the occasion. Tom Thumb weddings and pretend ceremonies with little ones playing bride and groom were popular in the first part of the 20th century. These happy children are dressed in their finest for a gala occasion in 1954.

Peter C. Campbell worked as a baggage carrier for the Central Railroad of New Jersey after immigrating to Middlesex Borough from Scotland. His wife, Monica, who immigrated from Austria, worked as a housekeeper for the La Monte family in Bound Brook and helped that family fete many famous persons. Monica's cookies were famous throughout the town. The Campbell's backyard on Dorn Avenue was plowed up every year by a team of rented horses, and a huge garden was planted, taking up the entire backyard.

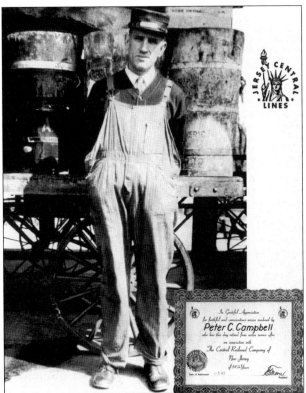

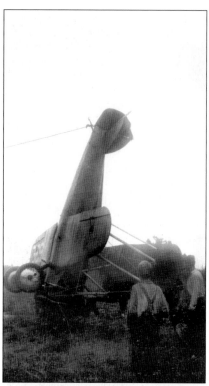

In the 1930s, a small airplane crashed in the Plainfield area sewage plant field, now an area of Mountainview Park. The plane landed upside down with its wheels facing the sky. Here the plane is being turned to an upright position. The pilot was not hurt, but the scene drew great attention.

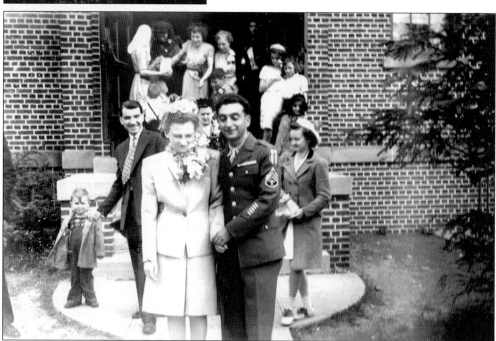

Pauline and Emedal DiMura are the happy bride and groom at Our Lady of Mount Virgin in May 1945. Wartime and postwar weddings were popular. Usually the groom was still in service or recently discharged but always handsome in military attire. Notice the bobby socks and saddle shoes worn by the girl on the right.

Typically dressed for the times, Edward (left) and Robert Johnson smile for the photographer in the 1940s. Both grew up to be lawyers who joined with their father, Edward Johnson Sr., practicing law in Middlesex. Members of the family were among the earlier residents of Middlesex Borough, living in the Beechwood Heights section. Both Edward Johnson Sr. and Edward Johnson Jr. served as borough attorneys for the town.

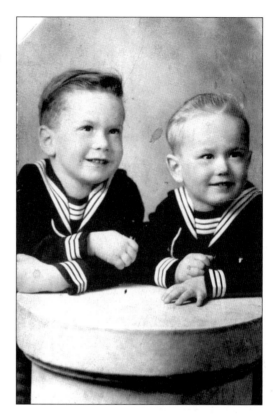

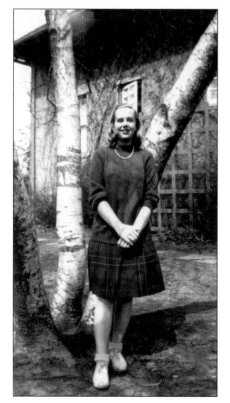

Nancy Lincoln Fields, daughter of George and Gladys Lincoln, is standing in front of her home in the 1940s wearing bobby socks, which were characteristic of that era. George Lincoln was one of the early mayors of Middlesex, and Gladys Lincoln was an active member and supporter of the Foothill Playhouse.

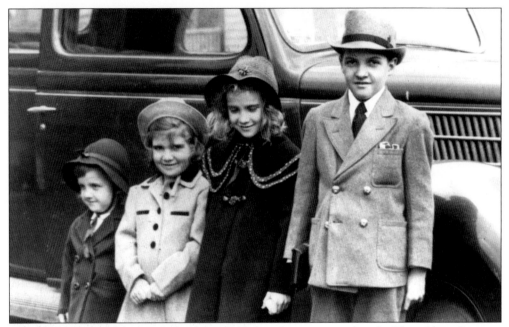

The Eberhart family is pictured in the 1940s on their way to church. The eldest, Dave, is dressed in the latest fashion with knickers and a hat with a feather. The girls are, from left to right, Connie, Janis, and Marilynn. The Eberhart family grew by three after this picture was taken, with the births of Quentin, Kathleen, and Gary.

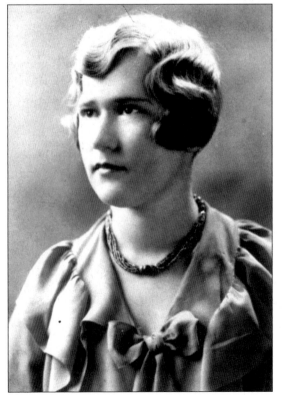

This lovely young girl of the 1920s later met and married a fledgling attorney. He was the 14th of 14 children, whose grandparents immigrated from Ireland in troubled times. She raised her young family with grace and dignity, instilling in them a strong moral sense and work ethic. Active in the Parent-Teacher Association, League of Women Voters, and other civic and political organizations, Mildred Huston Johnson is a good example of the spirit of Middlesex.

Thirty-year-old Joe Zuccarelli stands proudly before attending a local wedding in 1943. A sharp dresser, even to this day, this community leader was born in 1913, the year Middlesex became a borough of its own. The year 1943 is further important in his life, as his firstborn child, Emily, arrived in January of that year.

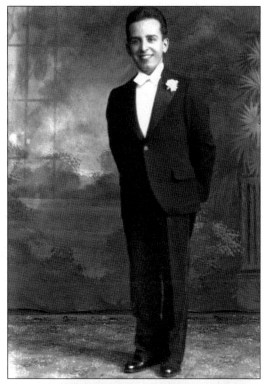

Kay Speer is shown standing in front of a store that would be called a convenience store today. The store, which was located on the corner of Greenbrook Terrace (Bound Brook Road) and Greenbrook Road, was operated by the Speer family for many years. It was sold to Charlie Drake in 1938. The building has since been destroyed and replaced with a house.

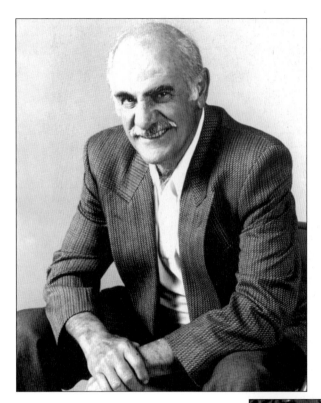

Tiger Andrews, famous movie and television actor, grew up in Middlesex and was educated in the Middlesex school system. He is probably best known for his role as Captain Greer in the long-running television series *The Mod Squad*.

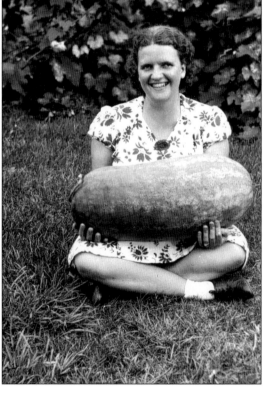

Phyllis Eberhart is posing proudly with a watermelon grown by her husband, Dr. Dale R. Eberhart. Phyllis used to can many of the fruits and vegetables grown by her husband. The entire backyard of the Eberhart property was dug up by shovel each year, usually by oldest son David, and each row of plants was meticulously laid out in parallel lines. Natural fertilizers were applied liberally to produce a bountiful harvest.

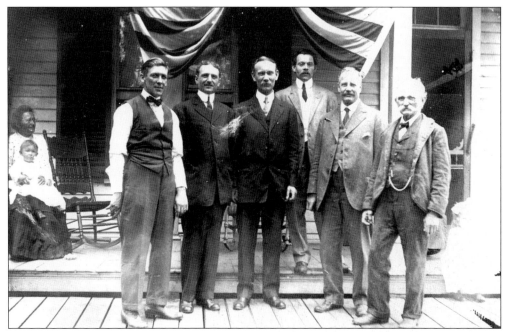

A festive Fourth of July celebration took place at 470 Harris Avenue in 1902. Even the baby, held by Henrietta Goering, joined in the festivities. Suits and ties, high collars and pocket watches were the order of the day. Jacob Goering stands on the right, and Pete Gordon's grandfather, Pete Schultz, is on the left.

October 25, 1957, was a routine day on patrol for officer Hal Hanania, until he was summoned to help deliver Gino Malone, and that made it a day that he never forgot. Hal Hanania was glad that he paid attention during the first-aid training he received as a young Middlesex police officer.

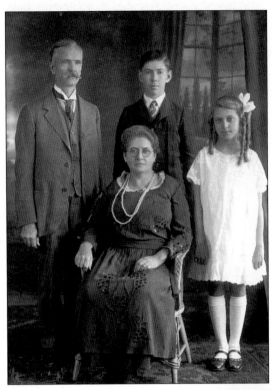

This 1924 photograph shows William Otto Frederick Finck and Nanse Finck with their children, Elsa and Carl. Finck moved to Middlesex on May 4, 1920, from Lynbrook, New York, to build a greenhouse range on Union Avenue. The greenhouses produced cut flowers for the retail market until the 1970s, when the property was sold for a housing development.

Arthur Moore worked in the administrative offices of Johns Manville, was a longtime member of the Beechwood Fire Department, and in 1915, was elected as justice of the peace for Middlesex Borough, a position he held for several years.

The Pettys were residents of Middlesex in 1913, the year the borough was established. From left to right are the following: (front row) Peter, Helen, and Angelo Petty; (middle row) Nicolina and Theodore Petty; (back row) James and John Petty. The dog's name was Rover.

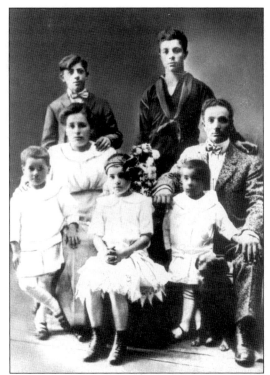

Charles Giles, the son of one of Middlesex's first councilmen, Nelson Giles, established the Giles Transportation Company, one of the earliest businesses of its kind in 1920. His father loaned his sturdy horses, Kate and Bill, to local firms in 1904 for hauling heavy loads. With the advent of the horseless carriage, Charles decided to take his father's nascent business to its logical next step.

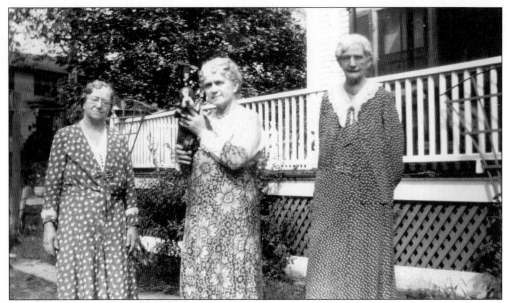

Long dresses, lace collars, floral prints, and carefully coifed hair were the style in the late 1920s. Large, open front porches adorned with white wooden railings and latticed wood protective barriers for the crawlspaces under the porches graced most of the early homes in Middlesex. Almost every family had its pet dog or cat. The woman in the center is proudly displaying the family dog.

Agnes C. Gall was familiar to many of the early residents of Middlesex since she taught mathematics in the elementary school from 1930 to 1973. She was instrumental in providing a thorough and efficient education to all who passed through her classroom. There were not many teachers who taught for 43 years in the Middlesex Borough school system.

A lovely young lady in the 1940s, Anne Bambo reflected the spirit of her times. Effusive and energetic, she and her husband, John Bambo, built Bambo's Bar, and their cheer and good will made it a favorite of Middlesex residents. They subsequently built and operated the Oxbow Restaurant, which is currently known as Carpaccio Ristorante. Anne was beloved by all who knew her. She and her husband, who was a big-game hunter, would travel to Montana each year so that he could hunt elk and bear. On their way to Montana, they would stop each year at St. Joseph's Indian School in South Dakota and deliver Christmas gifts to all of the children attending the school.

Robert Papa is dressed in his very best, all set for Easter Sunday on a bright day in 1959. It looks like the egg hunt is over and the goodies eaten, judging from the pleased look on his face. In the 1950s, dress coat and hat were standard church clothes for small boys.

97

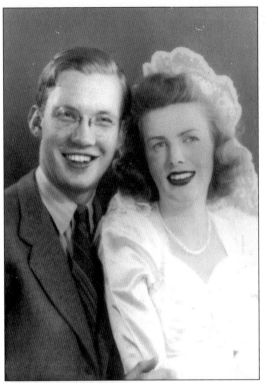

Bruce and Marion McCreary were married on March 4, 1944, in Darien, Connecticut. They moved to Middlesex in 1947, and Bruce accepted a teaching position in Rutgers School of Engineering. Bruce was a member of the Middlesex Library Board of Trustees and was involved in the planning for the original library building. Their home on Hazelwood Avenue was designed by Gustav Stickley, who was a well-known house and furniture designer. The home is now listed on the New Jersey and National Registers of Historic Places.

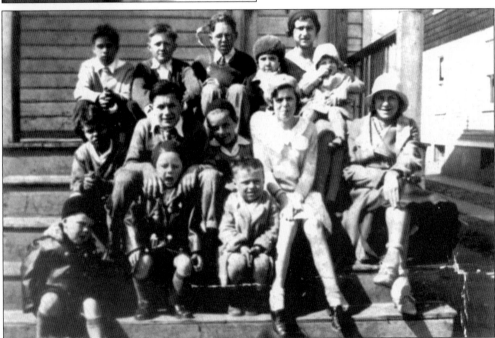

Large families were a characteristic of Middlesex during the years of the Great Depression. The Reilly and Stazo families are pictured sitting on the front steps of the Reilly house in 1931. Sitting on the front stoop was a favorite pastime of the era and a great place for communication within families and with neighbors.

Snow does not fall often in winter in Middlesex, but in the early 1950s, as this photograph shows, even a small snowfall was enough for Margaret and Eleanor Brown to try building a snowman. A very proud snowman it turned out to be, with its carrot nose, warm parka, and sturdy stick arms welcoming winter!

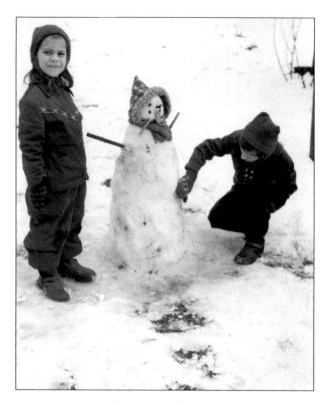

Shown here are Arthur S. Moore; his wife, Wilhemina; and daughter, Dorothy Moore (Morecraft), in front of their house on Prospect Place. Arthur Moore moved to Middlesex from Brooklyn, New York, when the Johns Manville Corporation moved to Manville, New Jersey. He served Middlesex Borough as justice of the peace. His daughter worked for Mayor George Harris, Middlesex's first mayor, who was also the president of the First National Bank of Dunellen.

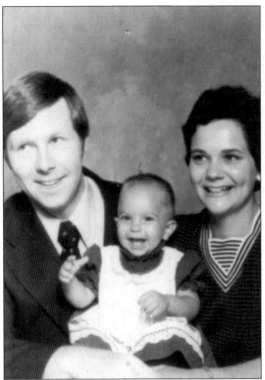

The Hoxie family is a typical Middlesex family, shown here in a picture taken in 1974. Janet was a teacher in the Middlesex school system. Jim served on the zoning board in town for many years and was an executive for the Hallmark greeting card company. Like many other borough residents, they shared their skills by serving the borough.

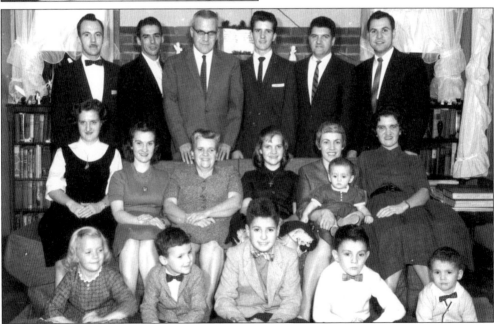

Large families were prevalent in the mid-1900s. Pictured here are Dale and Phyllis Eberhart, their seven children with spouses, and their grandchildren. Dale, an avid amateur photographer with his own darkroom in his house on Beechwood Avenue, made his own Christmas cards for many years. Many people in the 1940s and 1950s did their own photographic work, as this was a popular hobby of that time.

Lifelong Middlesex residents and local business owners William and Robert Ferris are the proprietors of Ferris Brothers Wholesale Florist, located on Union Avenue. Their father, Archibald Ferris, who managed the William Finck greenhouses prior to the purchase of the Ferris Brothers property, established the company in 1951.

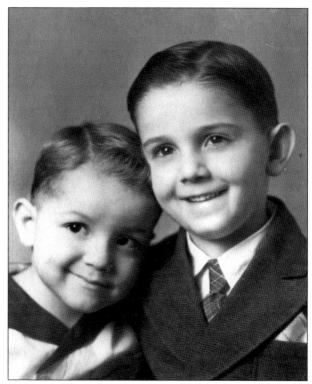

Ruthie Wharton does not seem too happy to be interrupted in her tricycle riding for a picture. Maybe the mittens hanging from strings or the cold bicycle handlebars are making her sad. In the early 1960s, when this picture was taken, little girls still wore their mittens on a string around their neck or clipped to their sleeves.

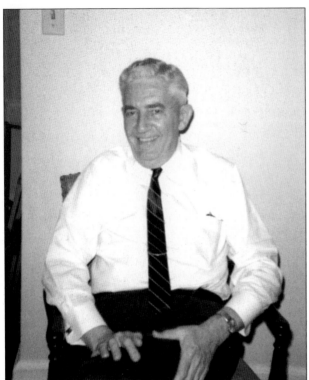

George Gould, former Middlesex councilman and founder of the first Boy Scout troop in the borough of Middlesex, is shown relaxing at his Grant Avenue home. A graduate of Stevens Institute of Technology and American University, he served as field director for the American National Red Cross in the India-Burma-China Theater in World War II. His postwar occupation was with the Johns Manville Corporation, where he was supervisor of personnel for 24 years. His wife, Ruth, was a prominent local Realtor who sold many homes in the borough.

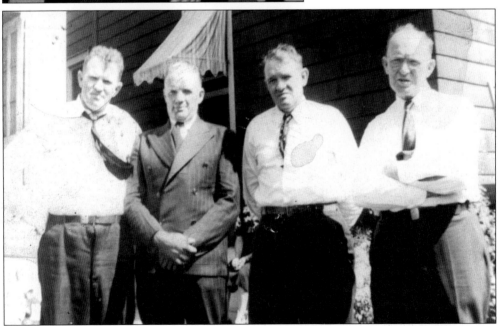

Standing from left to right, brothers John, Ike, Alex, and Bill Morecraft all became contractors and built many of the early homes in Middlesex Borough. John lived on Nutwood Avenue, and Bill lived on Dorn Avenue. Bill's daughter, Bertha Schneiderwind, lived on Grant Avenue, was active in the Middlesex Women's Club, and was a real-estate salesperson. White shirts and ties were the required dress in those days.

John Reilly is ready for the Indy 500 as he poses for this picture in 1960. The picture was taken on Fairfield Avenue. John and his family are currently residents of Runyon Avenue. All aspects of car racing have been of deep interest to John and father Charles, who is also still a resident of Middlesex.

Patricia Papa watched and waited impatiently for the Easter Bunny on Easter Sunday in 1959. She is pictured outside her house on Louis Avenue. This house is part of the Foothills Acres development built in the early 1950s by Arthur Ludovice and Ben Schwartz, working as L & S Home Builders. Many streets in the development are named after the builders, their spouses, children, and friends.

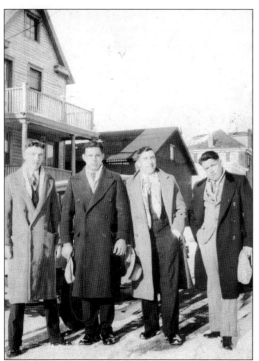

Lincoln Boulevard during the winter of 1925 was the gathering place for these residents. They are, from left to right, Julio Pepe, Eugene Borin, Tony Costa, and an unidentified friend. At the far right-hand side of the picture, the Lincoln Tavern can be seen. This was long before it was relocated down the block and across the street. The first floor of the two-story building in the picture was a grocery store. Scarves, overcoats, hats, and shined-up shoes were part of the winter dress scene at that time.

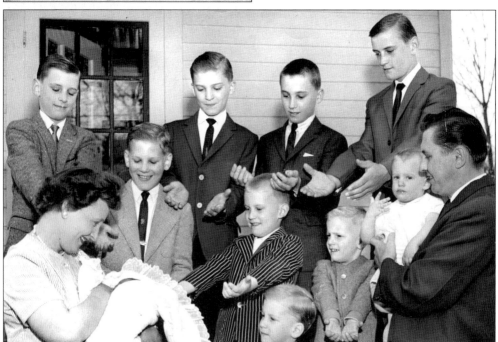

In 1964, the Rutkowskis of 303 Hazelwood Avenue welcomed the newest addition to their family, John Joseph. Along with the mother, Mary Ann, and father, Walter, are, in the back row, from left to right, Kenneth, James, Gary, and Thomas. Next to the mother are, from left to right, Robert, Richard, William, and daughter Mary Ann in her proud father's arms. Completing the group in the front is Mark.

Young George Osterman seems to be looking up at his mother with that cherubic smile, dressed in his Sunday finery with short pants, long white stockings, starched white collar, elaborate bow tie, and tweed jacket, asking, "What shall I do with these dirty hands?" Later in life, when he operated Osterman Nursery in Middlesex Borough, George would trade in his elaborate bow tie with a Western bolo string tie, which became his trademark.

Dorothy Osterman, the daughter of Henry and Elsa Osterman, is standing on Bound Brook Road (an unpaved two-lane road) in 1919, looking toward her home. Her father came to America from Germany, lived in Ohio, moved to St. Louis (where he met his wife, Elsa), and moved to Middlesex in 1929. He imported trees and plant materials from Holland and started a prosperous business, which eventually became Osterman Nursery.

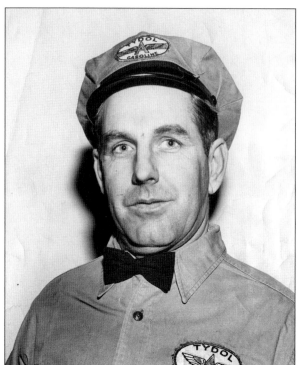

Jack Craig, chief of the Beechwood Heights Fire Company, was also the sole proprietor of Craig's Tydol gasoline station. The uniform worn by Jack while plying his trade is reminiscent of the uniform worn by the "men of Texaco" who sang the introduction for the Milton Berle television show in the early 1950s. Having a bow tie and peaked cap with the logo of the company prominently displayed was typical for this time.

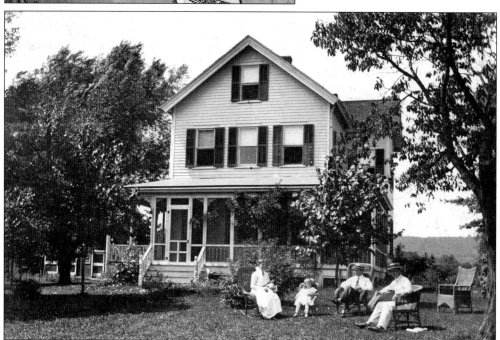

The original Osterman farmhouse on Bound Brook Road in 1918, which was known as Twin Brook Farm at that time, was the homestead of Mr. and Mrs. H.G. Osterman, who are shown here enjoying a late-summer afternoon with their family. Notice the straw hats, the wicker furniture, and the beautiful white dresses. Even while relaxing, people seem so in style in those days.

Five

RECREATION

This 1920 photograph shows Mattie Morecraft in the yard of her home on Dorn Avenue and is illustrative of the way young girls celebrated the coming of spring in this era. Some of the girls shown here are Bertha Morecraft Schneiderwind, Eleanor Morecraft Lower, Ruth Levenson, and "Queen of the May" Dorothy Moore Morecraft, who is standing at the maypole. May Day celebrations were common at this time, but there are probably not many people living today who remember this custom.

The results of the deer hunt in the fall of 1962 at the Hoski farm in Pennsylvania are displayed in front of the Hoski Flower Shop in the Middlesex Shopping Center. Pictured, from left to right, are community leaders and businessmen Joseph Hoski, Ed Boniakowski, Robert Agans, Earl Thompson, and Walter Rafferty. A number of the men stayed at the cabin of Zane Gray, the famous writer of the American West.

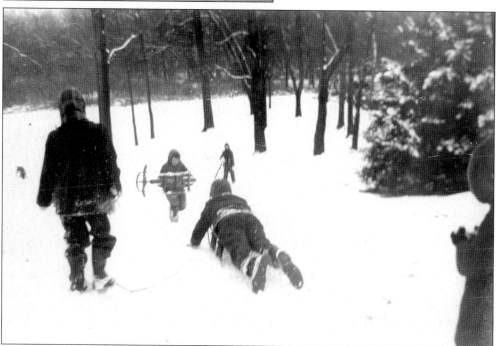

Sledding has always been a popular sport in Middlesex Borough in winter. The houses adjacent to the Green Brook on Beechwood Avenue had backyard embankments, which provided excellent snowy hills for Flexible Flyers. These children are pictured sledding down the hill behind the house at 129 Beechwood Avenue in the 1960s. Notice that people are carelessly sledding down the hill at the same time people are walking back up the hill.

The Foothill Playhouse, "New Jersey's summer theatre in a barn," was located near the northerly end of Beechwood Avenue. The Foothill Players were organized by Charlotte and Stanley Klein on June 7, 1947. The players first performed in a playhouse located on Route 29 (which is now U.S. Route 22), which burned to the ground in 1949. In 1951, the Foothill Players were given the use of the barn on Beechwood Avenue, which had been built in 1911. This became their permanent home.

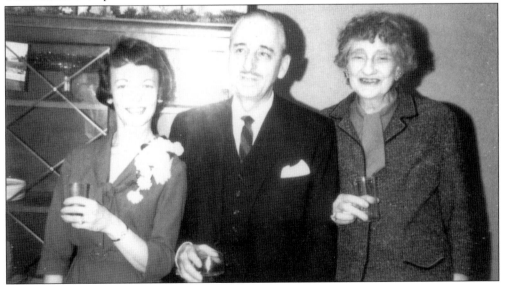

Pictured, from left to right, are Trudie Suabedissen, Stanley Klein, and Charlotte Klein. Trudie was the choreographer for the company and directed most of the dance scenes in the various productions, while Stanley and Charlotte were the founders and operators of the Foothill Playhouse and directed many of the shows produced by the company. They staged musical comedies, dramatic productions, and most of the Broadway productions of the time at their intimate little theater.

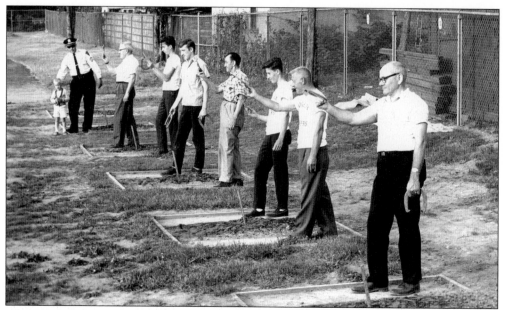

The most popular horseshoe-pitching area in Middlesex Borough before the establishment of the world-class pits in Mountainview Park was at Cook Field. Supervising this competition in the early 1950s is Hal Hanania of the Middlesex Borough Police Department; he was a prime mover in the promotion of horseshoe pitching as a recreational activity for all ages.

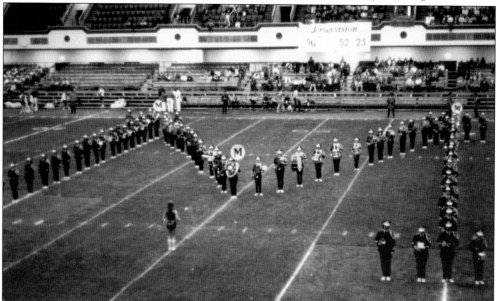

The Middlesex High School marching band displays its letter M for Middlesex for the fans attending the New Jersey high-school championship game at Atlantic City, where Middlesex played Hillsborough for the state championship. The Blue Jay band was famous for its high-quality musicianship as well as for its marching ability, and this high-quality entertainment was a trademark of the Middlesex school system since the high school opened in 1961. Dominick Pirone was the director of the music program and was liked and respected by both students and parents alike. He made everyone love and appreciate music.

This group of vacationers is shown getting ready to board the plane from Hawaii to return to Middlesex. The woman dressed in black in the center of the picture is Mabel S. Boyer, who was a teacher in the Middlesex Borough school system and died in 2001 at the age of 106. Standing next to her is her husband, William Boyer, who was the borough's first superintendent of schools. From the looks of those clouds, these passengers better hurry up and board the plane or they are going to get wet.

Nattily garbed for the occasion are these participants in the annual Efinger Sporting Goods Tennis Tournament. The competition was held in the 1930s at the courts on the corner of Beechwood Avenue and Route 28, on the site that now houses the dentist office of Dr. John Fahsbender, formerly the office of Dr. Douglas Levy. William Efinger is in the center, and Guy Stryker is on the right.

Gail Paradis was a participant in the fishing derby held at Victor Crowell Memorial Park during the 1950s. At this point, she is more concerned with having her picture taken than with catching a fish. The lake and its surrounding landscape provided various forms of recreation for its neighbors and other residents throughout the years. Nature observers and hikers can be seen on the other side of the brook.

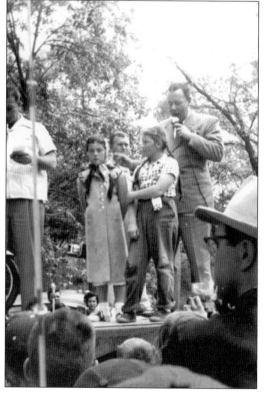

Here, the winners of the annual fishing derby held at Victor Crowell Memorial Park are announced after the competition. These winners were contestants during the 1950s. Victor Crowell Park was developed under the guidance of Mayor John Rafferty and Mayor Chester Lydecker in 1936 and 1937 by the Works Progress Administration and has been the scene of varied and sundry recreational activities by community members up to the present day. The park was recently renovated thanks to several grants in excess of $1 million received through the efforts of Mayor Ronald S. Dobies.

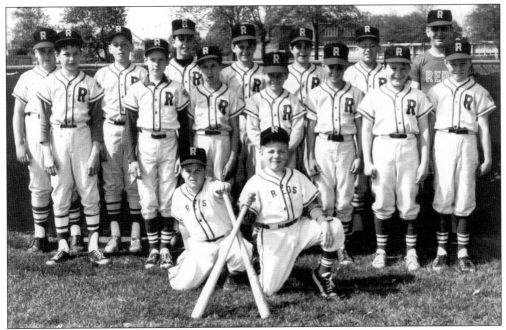

Members of the 1968 Reds baseball team stand proudly at the Little League field. Manager Steve Fellin was one of the motivating and driving forces in the Little League program in Middlesex Borough. The present Little League field is named for him. He is shown in the upper right-hand corner of the picture. Steve has spent a great portion of his life fostering the growth and development of the Little League program in the borough.

In the 1930s and 1940s, the residents of Middlesex often saw Joe Verebly driving his Ford Phaeton convertible with his No. 99 racecar in tow. Known at major speedways from Connecticut to Florida for his competitiveness and hard-driving skills, Joe had a distinguished career and survived several major crashes before retiring in the 1950s.

Middlesex Little League was established in 1952, and the teams played their first games on a field located next to the Thomas Young greenhouses on Harris Avenue. The league was originally sponsored by the Middlesex Borough Recreation Commission but became self-sustaining shortly thereafter. The league moved to its present field at the corner of Pierrepont and Wellington Avenues in 1959. The second floor of the building was built by volunteer parents of Little League participants, and much of the wood and other supplies were furnished free of charge by the Newchester Construction Company, which was in the process of constructing the Middlesex Village Apartments.

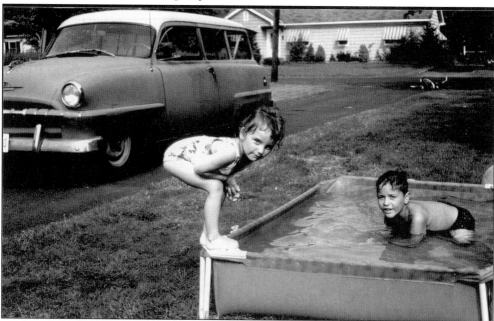

Even though Middlesex Borough had its own municipal community pool in 1965, Lee Ann and Ken Shepard preferred to practice their swimming skills in the privacy of their own backyard pool. Lee Ann is getting ready to dive into the lovely cool water, while Ken seems a bit more apprehensive. The two-tone family Chevrolet station wagon is parked in the driveway, showing the preferred method of family transportation at the time prior to the advent of the minivan.

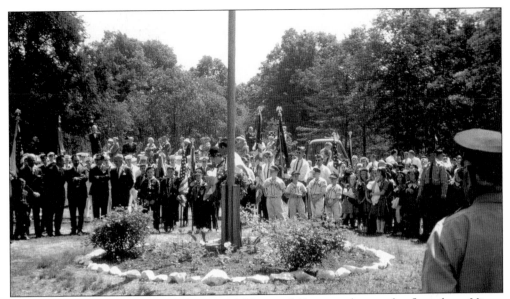

For years, the starting point of the annual Memorial Day parade was the flagpole at Victor Crowell Park. The park was originally named Willow Park, but the name was changed to Victor Crowell Park to commemorate the life of Victor Crowell, the first person from Middlesex Borough to be killed in World War II. Pictured here are community leaders, members of the Veterans of Foreign Wars and the American Legion, Little League players, and borough citizens, who all gathered together as part of the festivities and ceremonies of that most meaningful day.

The Foothill Playhouse productions offered many opportunities to foster talent in people of all ages. These aspiring ballerinas, students of "Miss Trudie," are pictured here practicing at the barre for a dance scene. Trudie Suabedissen taught ballet in Middlesex Borough and was closely associated with the playhouse. Be it comedy, drama, or musical, patrons always eagerly anticipated the summer evening plays in the old barn.

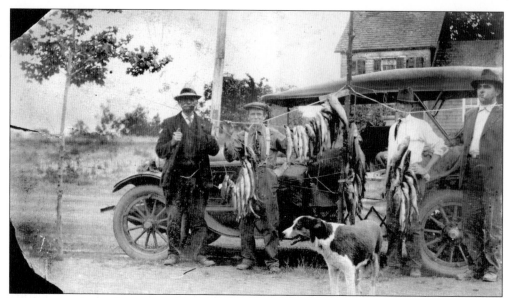

This picture shows the return of four Middlesex residents from a successful fishing trip. All of the fishermen wear shirts and ties, as well as hats to fend off the sun's rays. Suspenders help support the trousers of the youngest sportsman. The watch chain, a status symbol of the times, can be seen on the gentleman at the far left side. Even the family dog joins in on the fun.

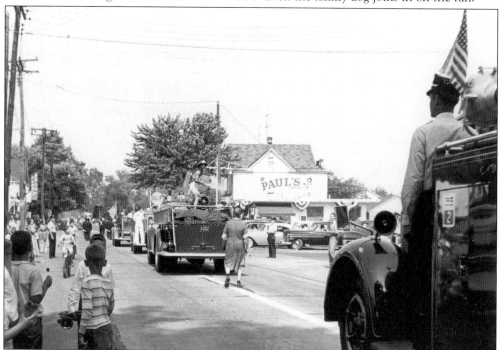

A line of fire engines proceeds proudly past the corner of Bound Brook Road and Lincoln Avenue during the parade held in 1963 to celebrate the 50th anniversary of the borough. The photograph, which marks a memorable event, shows the children of the community enjoying the passing parade. Note the physical changes on this section of Bound Brook Road in the last 40 years.

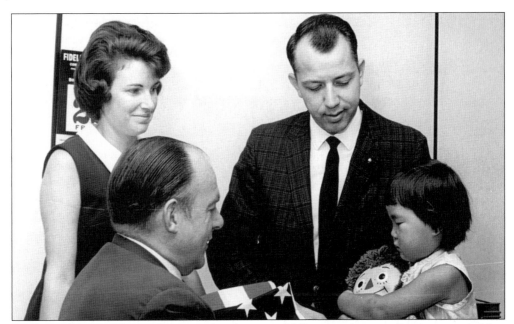

At the tender age of four, a Korean orphan became a U.S. citizen in naturalization court in New Brunswick. Kathleen Sueann Ferris, daughter of Catherine and Robert Ferris, is shown here hugging a Raggedy Ann doll. The doll was presented to her before the ceremony by Mayor Charles S. Judson. Along with her new doll, Kathleen was given the flag of her adopted country.

Monica Ciliberto (Esposito) in 1969 is surrounded by Raggedy Ann and Raggedy Andy dolls in celebration of Raggedy Ann's 55th birthday. Known for their red hair, big grins, red striped stockings, and their hearts bearing the words "I love you," Raggedy Ann and Raggedy Andy were manufactured by the Knickerbocker Toy Company in Middlesex between 1962 and 1982.

Biking was a favorite mode of transportation in the 1920s, and knee-high socks and rolled-up pants or knickers were the fashion for bicyclists. Bicycles had only one speed, and hand brakes had not yet been invented. This bike was one of the first off-road, all-terrain vehicles of its time and was used to cross fields, as well as to travel on roadways.

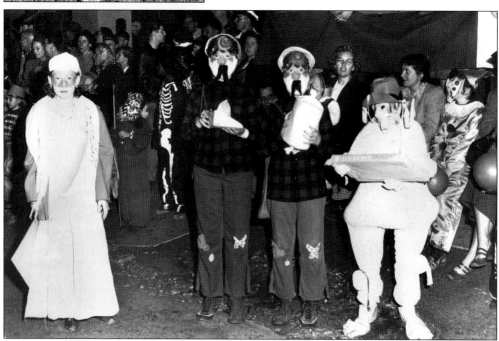

On the night of ghosts and goblins and scary things that go bump in the night, the annual Halloween Parade for children has long been a much anticipated occasion. The masked winners of the competition for best costume are shown displaying the results of their (or Mom's) imagination in 1953.

This picture was taken in the early 1930s on Grant Avenue in Middlesex. Pictured are Kathryn and Lois Ulmer, Margaret, Neil, and Merrett Wertheim, and Francis Sepesi. In front of them is everyone's best friend, enjoying the attention.

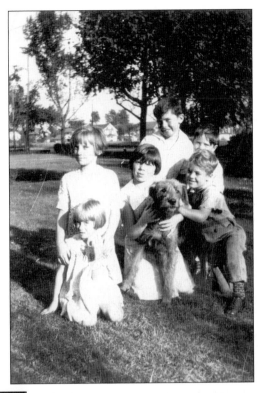

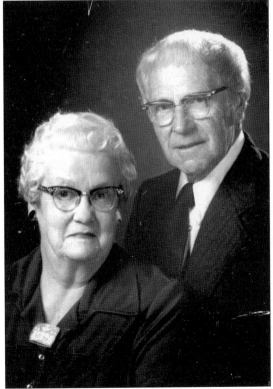

William and Elizabeth "Lib" Howes were outstanding citizens of the borough who used their talents to make Middlesex Borough a better place in which to live. She was very active in the Middlesex Women's Club. He was the secretary for the board of education for many years, a member of the borough council, and the first president of the Middlesex Library Board of Trustees; he remained president for almost his entire tenure on the board because of his excellent service.

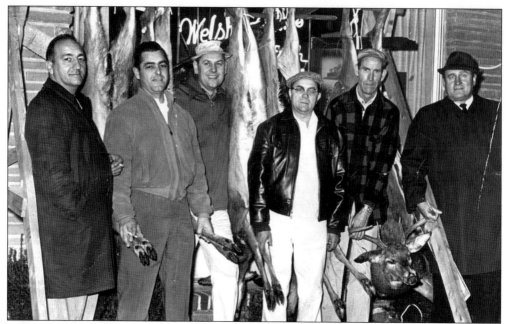

Displaying the results of a deer hunt in front of local business establishments was a common practice during the 1950s and 1960s. Standing in front of Resch's Bakery in a strip mall in Middlesex are, from left to right, Frank Curcio, Joe Crivello, George Plesa, Louis Resch, Earl Thompson, and Bob Agans.

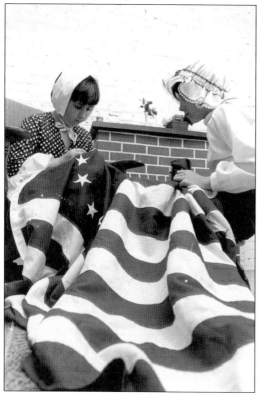

In June 1976, the country's bicentennial year, many schools took part in state-sponsored patriotic projects. Here, two Pierce School students are at work sewing stars on fabric to complete the creation of an American flag. Notice the colonial ribbon-adorned caps worn by the 10-year-old girls sewing the flag.

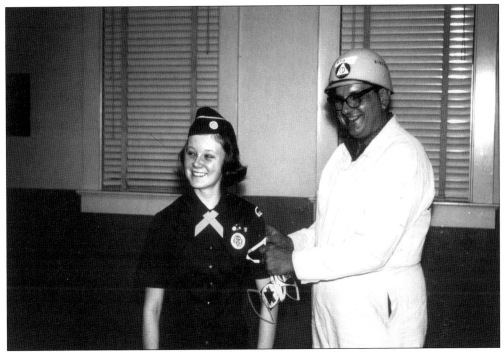

Bill Engelman, head of civil defense in Middlesex Borough, is shown here awarding a new patch to one of the local Girl Scouts in town for having completed part of her Girl Scout training.

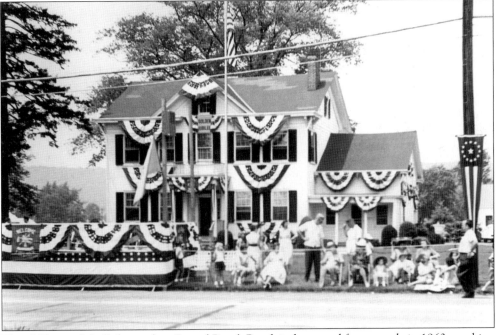

The old borough hall, located on Bound Brook Road, is decorated for a parade in 1963, marking the 50th anniversary of Middlesex's incorporation as a borough. Community leaders worked long and hard to formulate plans for the celebration honoring a thriving community that was forged by courage and conflict.

The Middlesex Rangers 1938 football team featured players whose families were some of the earliest residents of the borough. The players are, from left to right, as follows: (front row) Robert McDermott, Steve Sunyak, Frank Butula, Andrew C. Simpf, James Hausman, Joseph Doochack, William Frohbose, and Paul Pfister; (middle row) James McDermott, Louis Sokolitch, William Allison, Eck Fuller, Edward Kays, and Edward Kelley; (back row) Albert Vogel, Jack Fuller, Edward Kulpak, Joseph Doochack, Phillip Reilley, Daniel Tesar, Frank Pasek, and Charles Kush.

Boys are pitching horseshoes during a lunch break at Watchung School in 1940. The building in the rear still stands on the corner of Fisher and Cook Avenues. Horseshoe pitching became popular with the advent of Mountainview Park and the formation of the Middlesex Horseshoe Pitching Club. The horseshoe-pitching facilities at Mountainview Park are rated as some of the best in the entire state. The club is still in existence today, with a very active membership.

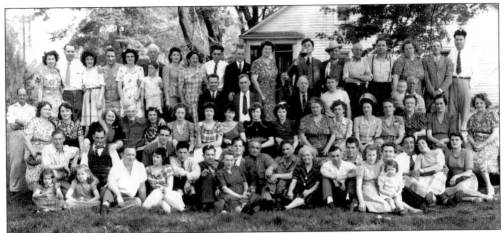

On a summer day in 1943, the Middlesex Manufacturing Company, a local plant having its facility located on Lincoln Boulevard, gave a picnic for employees and their families. The company manufactured government materials to help further the war effort. Some people wore suits, and some wore casual wear. One woman had on a military hat, one man had on a cowboy hat and scarf, and most everyone else was hatless. Can you pick out the one soldier who attended this picnic?

The R & L Club sponsored a local basketball team in the 1960s, and this picture shows the team posing at the gym where the team practiced. The letters R & L were an abbreviation for Right and Left Club. Money was tight in those years, and it seems that some of the players got team shirts while others wore their own white tee-shirts. From left to right are the following: (front row) Ralph Eberspacher, Robert Ferris, and Ed Szaro; (back row) Charles Shearn, Tom Neil, Charles Dorsey, Larry Bernstein, and Philip Shearn.

FOOTHILL PLAY HOUSE

1947 ● FOURTEENTH SEASON ● 1961

New Jersey's
Summer Theatre
In A Barn

Presents

"DARK OF THE MOON"

by HOWARD RICHARDSON & WILLIAM BERNEY

(By Special Arrangement With Central Library Inc., New York)

August 2, 3, 4, 5 and 9, 10, 11, 12

In 1951, the Foothill Players were given the use of the old barn on Beechwood Avenue, which had been built in 1911 by Joseph Johnson, fire commissioner of New York City. The barn was converted into a 176-seat theater in 1952. The hayloft became the balcony, and the patio was once a creaky, overhanging shed. All actors performing at the theater worked for free. The great main curtain was a hand-stitched crazy quilt made of remnants from the sewing rooms of housewives of the area. The cow stalls became tiny dressing rooms. The milk shed became the actor's lounge. Refreshments were served in the old corral, and cowbells were used to signal curtain time.

Superintendent Von E. Mauger serves as the referee for the opening tipoff in a basketball competition held at Watchung School during the 1950s. Mauger will always be remembered for his warm relationship with students and his dedication to their total welfare. The experience obtained from this activity probably helped prepare him to referee issues and controversies at board of education meetings. The success of his job was reflected by the fact that there were no major controversies during his tenure as superintendent. Mauger was everyone's friend and gave unstinting help and guidance to all.

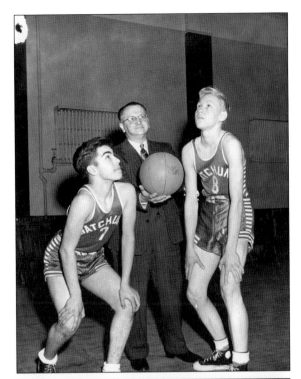

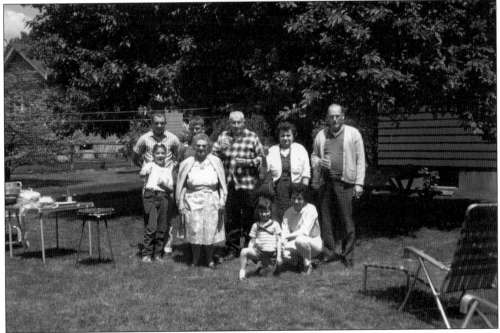

The Shepherd family is shown relaxing at a family picnic in their backyard on a sunny summer day. The luxurious deciduous shade trees provided a cool respite from the sun, while the hamburgers broiled on the portable charcoal grill. Lawn chairs, picnic table, and a portable card table were necessary accouterments for any outdoor picnic. Outdoor family gatherings have always been a favorite pastime in Middlesex Borough.

Members of the Middlesex Borough chapter of the American Legion are shown at one of their ceremonies held in their building on Legion Place. The group was formed in 1944 by about 70 original members. The first commander was Frank Moran, and two of the early organizers were Samuel Frank and Charles Bradley. Post members are vitally interested in child welfare and rehabilitation work, and the post annually sponsors a delegate to the New Jersey Boy's State Convention, where youths learn the fundamentals of government during a one-week session.

Martin Matuskiewicz, who served in the positions of mayor and fire chief for a number of terms, is marching joyfully in this photograph of the 1963 parade marking the 50th anniversary of Middlesex Borough. This popular and respected community leader always had the welfare of the citizens in his mind and heart.

126

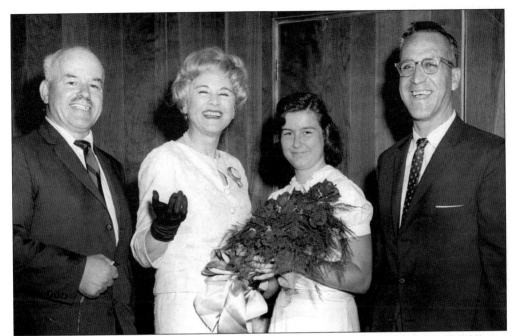

The Flowertown Parade in 1963 marked the celebration of the 50th anniversary of Middlesex. Shown here are some of the important people who were part of the festivities. From left to right are the parade organizer (name unknown), show business personality Hildegarde, Barbara Schnitzpahn (presenting a bouquet of flowers to Hildegarde), and Mayor Jasper Correnti.

The name John Haverstick and Middlesex recreation are synonymous. Haverstick served as director of the Middlesex Borough Recreation Commission for many years, and the borough recognized his years of outstanding service by changing the name of Seneca Field to John Haverstick Field.

Charles Morgan ("Mr. Phillies Fan") dedicated his life to his family and the youth of this community. Charles headed up every aspect of the Middlesex Elks Youth Activities Program, recognizing student accomplishments in the playing field. He ran the annual Hoop Shoot Program and coached Little League and Babe Ruth League teams. In 1990, he was recognized as Elk of the year.

Fred Worowski, superintendent of parks and playgrounds for the borough for many years, performed his duties in an exemplary manner. Freddy, as he was known, was always going beyond what was expected of him. He could often be seen on weekends and in the early-evening hours, after completing his work for the borough, lining the baseball fields, manicuring the pitcher's mound, watering the various ball fields owned by both the borough and the board of education, and doing whatever needed to be done to ensure that the fields were ready for use at all times. The field behind the high school has been named Fred Worowski Field in his honor.